D0886515

Documents on
Contemporary Crafts

No. 4

On Collecting

André Gali (ed.)

NORWEGIAN CRAFTS
2017

Table of Contents

Preface

In December 2016 I visited Design Miami/ and discovered I could not find a single craft artist from Norway represented at the famous fair. Design Miami/ had more than 37,000 visitors that year, the majority of whom are collectors in one way or another.[1] With such a huge opportunity missed, it became clear to me just how important it is for Norwegian Crafts to keep introducing Norwegian contemporary crafts to the international market, to ensure that 'our' artists, and more specifically their artworks, become part of private and public collections.

In Norway, private collectors are scarce, and more often than not, private collections remain just that – private. The museums are usually left to fend for themselves, and although Norway has enjoyed a modicum of fame in recent years for having had the means to support the arts, the times they are a-changing. In other countries, for instance the USA, the situation is almost the opposite: private collectors typically donate their collections to public museums and thus play an instrumental role in supporting the arts.

But who are these mysterious collectors? How do they choose which artists to support, and what is the reasoning for selecting one work of art over another? To collect art is an act that is entangled in many things, aesthetics being the obvious one, but also politics, economics, social identity and indeed psychology, all of which you can read more about in this book on the art of collecting.

In the large eco system of makers, artists, curators, museums, galleries, art historians and critics comprising the contemporary crafts field, collectors are just one piece of the puzzle. Organisations like Norwegian Crafts make up another piece, working for, with and alongside our peers in order to push the envelope on contemporary crafts. We facilitate communication between Norwegian artists and international artists, between institutions, curators and collectors to ensure that showing works of art at fairs or in exhibitions is never the end point of an artistic journey, but a step towards new endeavours. Our work may contribute to an artist getting a new show in an important institution, or having his or her work acquired by a museum or

1 Design Miami/press release Dec 2016.

private collector. The key is to keep pursuing interesting discussions within the field.

Over the last year we have raised discussions on collecting in New York, Munich and Oslo. Excerpts from these discussions are available in this book, in addition to new texts by Glenn Adamson, Paul Derrez and Anthony Shaw and a previously published history of collecting by Gunnar B. Kvaran. We are very thankful to the Royal Norwegian Consulate General in New York, The Ministry of Foreign Affairs, and Public Art Norway (KORO) for their close collaboration with us in organising and hosting these discussions. KORO was our collaborative partner for the seminar 'On Collecting' in Oslo in October. We are also very grateful to Arts Council Norway for its support, which has enabled us to produce the series *Documents on Contemporary Crafts*.

Hege Henriksen
Director, Norwegian Crafts

On Collecting: From a Public, Private and Personal Perspective

Art collectors and collections make up an important part of the contemporary arts and crafts infrastructure. Art collectors and museums help improve the financial situation of artists by buying their works, but just as important is the symbolic meaning of such collections. To be included in the 'right' collection or museum can give an artist a high level of recognition, at the same time as the purchase secures the work a place in a system that intends to preserve it for the future. To collect is a selection process which has economic, social, political and art historical implications and ramifications for the artist, the art field and the public.

Over the last few years, a number of discussions have been raised in Norway and internationally about *who* is represented and *what* is included in art collections. Karin Hindsbo (director of KODE – Art Museums of Bergen), among others, has pointed out the dominance of male artists represented in museum art collections, and the art newspaper *Morgenbladet Kunstkritikk* (1/2016) has called for a comprehensive and proactive 'collection policy' from the National Museum in Oslo. At the same time, we see an increased interest in private collections, with more and more museums including privately owned collections in their exhibition programmes. The exhibition *Love Story – Works from Erling Kagge's Collection* (2015) at the Astrup Fearnley Museum[1] is one such exhibition, exclusively showing works from Erling Kagge's collection. Kagge, a well-known explorer and publisher, shares some of his thoughts about collecting in the book *A Poor Collector's Guide to Buying Great Art*[2] that accompanied the exhibition. Among other things, he mentions private and personal collecting.

1 http://afmuseet.no/en/utstillinger/2015/love-story
2 Erling Kagge: *A Poor Collector's Guide to Buying Great Art* (Oslo: Kagge forlag, 2015).

Private and personal collecting

As Gunnar B. Kvaran points out in his essay in this present book (Kvaran initially wrote the essay for the online catalogue accompanying *Love Story – Works from Erling Kagge's Collection,* and which we've been allowed to reprint here in its entirety), art has existed since ancient times, and the private collector has played an important role in conserving meaningful works of art. It is only since the Eighteenth Century that museums have been the primary venues for seeing and discussing art, a situation that has to do with the emergence of the bourgeoisie and the public realm. In museums you find (what appears to be) a rational selection of works, hence the private collector takes on the role of challenging the established notions of 'taste', but also of supplementing the museums' collections.

For Kagge, as he describes in his book, collecting art is a way into an unknown world – the artworld – that he seeks to explore. Kagge admits to being beholden to gallerists like Eivind Furnesvik of STANDARD (OSLO), whose knowledge of art and the artworld has benefited him greatly. Furnesvik – considered to be among the 'movers and shakers' in the artworld – has over the last decade established his gallery as perhaps the most important Norwegian gallery for contemporary art, exhibiting at important art fairs such as Art Basel and Frieze. The gallery represents prominent artists such as Matias Faldbakken, Tauba Auerbach, Gardar Eide Einrasson and Oscar Tuezon – artists you're likely to see represented in exhibitions such as the Venice Biennale, the Whitney Biennale or Documenta.

While Kagge seems to see collecting as a challenge to overcome, almost like a game of betting on a fairly unknown artist who may turn out to be the next Picasso, other private collectors think differently about how and what they collect. This we learn from the essays in this book that are written by the collectors Petter Snare, Paul Derrez and Anthony Shaw.

Meanwhile, there are some more fundamentally human and universal sides to collecting that are also worth exploring. Psychological aspects of collecting are discussed in the essay which Dr. Margaret Wasz contributed to this volume. It offers startling insights we all can relate to. The psychology of collecting is also at the core of the art project *Collectors*, which the artist Yuka Oyama presents in her contribution. Oyama has met with collectors of different objects – typewriters, moon shelves, Space Age furniture and so forth – to discuss their rela-

tionship with the objects they collect. This has resulted in a series of fascinating photographs of the collectors wearing paper masks; they end up resembling the objects they collect.

Private collections and public museums

Relations between private collectors and public museums can be complicated, particularly as regards donations, depositions and lending, which are growing trends in Norway. Here I think especially of the billionaire and art collector Stein Erik Hagen. He has entered into negotiations with the National Museum for Art, Architecture and Design in Oslo (henceforth the National Museum) about lending the museum works from his Canica Art Collection. It is commonly acknowledged that this collection includes a broad range of works that supplement the works in the National Museum. The Canica Art Collection is valued at NOK 1 billion and ranks as the largest art collection in private ownership in Norway. Public enthusiasm was therefore great when Hagen, earlier in 2016, announced that he would give the National Museum full access to loaning works from his collection. Shortly after the announcement, however, a cloud of doubt loomed over the agreement, as an article on the website *newsinenglish.no* 24 August 2016 relates:

> Concerns soon arose, however, that not even the new and expanded National Museum would have room for all of Hagen's art /.../ In early July came news that Hagen was pulling out of his agreement with the National Museum after all.[3]

The reason for this turn of events relates to the fate of the National Gallery, part of the consolidated National Museum, when it opens in a new building in 2020. It has been suggested that the National Gallery's current premises (purpose built in three stages, from the late 1880s to 1924) should remain part of the National Museum, but the government has not yet made its final decision. If this building is not included as a branch of the new museum, Hagen and a number of curators at the National Museum fear there will not be enough room to show Hagen's collection in a significant way. In August 2016, Hagen met with cul-

3 Newsinenglish.no: Drama rolls over collector's art, http://www. newsinenglish.no/2016/08/24/drama-rolls-over-collectors-art (last visited 17 November 2016)

tural minister Linda Hofstad Helleland to discuss the outcome of this agreement. Hagen has put the agreement on ice until Parliament, in 2017, votes on the destiny of the National Gallery's current premises, but the cultural minister seems optimistic. The situation, however, reminds us that the relationship between private collectors and public institutions may involve many concerns with both personal and political implications. In fact, the Canica Art Collection has now become a political argument for keeping the National Gallery's current building as part of the National Museum, even after the new museum building opens in 2020.

The complex concerns related to private collections that are about to enter public museums is a topic that the art historian and former director of Northern Norway Art Museum, Knut Ljøgodt, discusses further in his essay in this book. While private collectors may choose art according to taste, and while they may support the artists they find most interesting from a personal perspective, public collections and museums are obliged to collect on behalf of society and posterity: their mandate entails that they collect works that are representative for significant cultural and historical tendencies and discourses. Public museums are also collecting 'for the ages' without necessarily thinking about art as an investment in the financial sense. Ljøgodt himself has worked with a number of private collectors and donors during his time as museum director, and he thinks this kind of collaboration is important and necessary; still, one of Ljøgodt's important points in his essay is that Norway should set up a substantial national fund that can secure works of art for the collections of Norway's public art museums.

On Collecting: the seminar
The relation between private and public collecting was one of the important topics we wanted to discuss when Norwegian Crafts and KORO (Public Art Norway), in October 2016, collaborated on organising the seminar *OOn Collecting: From a Public, Private, and Personal Perspective.*[4] The seminar built on a conversation held by Norwegian

4 *On Collecting: From a Public, Private, and Personal Perspective* first took the form of a seminar in Oslo on 13 October 2016, and was organised through collaboration between Norwegian Crafts and KORO (Public Art Norway). For more information, see: http://www.norwegiancrafts.no/projects/ on-collecting-from-a-public-private-and-personal-perspective

Crafts, Galleri Format Oslo and Art Jewelry Forum in New York in May that year. In the conversation, art historian Glenn Adamson and editor and art jewellery collector Lindsay Pollock discussed collecting contemporary crafts from a public and a private perspective.[5] Adamson shared interesting perspectives on differences in collecting between Europe and the USA, drawing on his experience from the V&A in London and MAD Museum in New York. While public museums in Europe are mostly state funded, it is more common in the USA that private collectors donate their collections to the museums.

In the seminar we explored two main questions:

How do the dynamics between artists, galleries, art fairs and private and public collectors influence the art field and market?

What financial, political and cultural structures are responsible for how works of art become 'collectable' and thus available to the public in museums and public spaces?

The moderator of the seminar was Liesbeth den Besten, an art historian who has written the 'bible' on contemporary jewellery: *On Jewellery: A Compendium of International Contemporary Art Jewellery.*[6] Also a collector of contemporary jewellery, den Besten, in her essay, discusses whether museums have better knowledge and authority on collecting and presenting jewellery than do private collectors. Many important collections in museums in the USA and Europe started out as private collections and were later donated to museums. But, as demonstrated by the fate of Helen Drutt's collection, which she donated to the Museum of Fine Arts in Houston, oftentimes the works may 'disappear' into storage rooms and into cultural oblivion. (This is what Stein Erik Hagen fears for the Canica Art Collection). In response to this tendency, den Besten has been part of an initiative among Dutch

5 Conversation and book presentation, The Residency of the Consul General in New York, 5 May 2016. See: http://www.norwegiancrafts.no/projects/on-collecting

6 Liesbeth den Besten: *On Jewellery: A Compendium of International Contemporary Art Jewellery*, (Stuttgart: Arnoldsche Art Publsihers, 2011) (reprinted in 2012).

collectors to establish a House of Jewellery that caters to jewellery collections and to presenting them in ways that will engage viewers.

To view works acquired over time as 'a collection' will in many respects also mean that the works are discussed in publications, not merely as important works in themselves, but within the context of when, why and how they were acquired. These are questions that Trude Schjelderup Iversen of KORO (Public Art Norway) discusses in her essay in this book. Over the last 40 years KORO has acquired art for public spaces and new buildings; today the number of works reaches as much as 7,000. But until recently, KORO did not see these works as being part of a collection. Recent developments within KORO, however, have led to a renewed thinking about the works produced in the past, and collection management is one aspect of KORO's work that has received increasing attention. Iversen also sheds light on the situation in Norway through comparing it with the Hessel Collection in the USA, one of the most researched and curated collections in the world.

On Collecting: the book

While planning the seminar, we knew we wanted to make a publication that extended beyond the seminar's scope. A seminar has its limitations. Time and space, accessibility for the audience – obviously, a limited number of people would have the time and opportunity to come to Oslo for it. Furthermore, much of the potential target group in Oslo might be unable to attend. We therefore wanted to make the seminar lectures available in edited form, as well as to include essays from people with great knowledge and experience in the field of collecting. Altogether, the contributions to this book shed light on the subject from many perspectives.

The seminar worked out very well in many respects, elucidating a diversity of perspectives on the theme of collecting: that of a psychologist (Dr. Margaret Wasz), an artist (Yuka Oyama), a jewellery curator (Liesbeth den Besten), an art historian (Knut Ljøgodt), a gallerist (Eivind Furnesvik), a private collector (Petter Snare), a public art institution (Trude Schjelderup Iversen), and from the perspective of a national acquisition fund for crafts (Nanna Melland).

I think Nanna Melland's essay on the Norwegian Craft Acquisition Fund, which purchases works for the three museums that specialise in craft in Norway, is of particular interest. This fund is fairly unique

as a model for collecting – a similar fund does not at this moment exist for contemporary or historical arts (even though such a fund has existed in the past and is something Ljøgodt, for one, suggests for the future). Through this model, craft artists and museum curators work together to secure the purchase of important works of craft for the three museums, thus constantly strengthening and updating the museums' collections.

On the other end of the spectrum is the private collector, who may not have a well-cogitated strategy, but whose passion for art may supersede that of someone who collects for a public institution. For Petter Snare, holidays and vacations are devoted to experiencing art, and as long as his budget allows it, he supports and is loyal to the artists of his choice. It may be interesting, from the view of contemporary crafts, to notice that Snare's gateway to becoming an art collector was through contemporary crafts. This is one of the issues he dwells upon in his essay.

Even though we felt we covered the range of perspectives on collecting fairly well during the seminar, we wanted to emphasise private collectors because their experiences are rooted in a passion for art or craft. Learning what private collectors have to say could shed light on the transition from just buying works to becoming a collector. We are therefore very happy to include texts by Paul Derrez and Anthony Shaw in this volume. Derrez runs Galerie Ra in Amsterdam – a gallery for contemporary jewellery that just celebrated its 40 year anniversary. He is a jewellery artist himself and, together with his husband, a passionate collector. He shares with us some of his thoughts on collecting, also reflecting on what to do with the collection in the future, and what challenges may come with donating the works to a museum. Shaw is another passionate collector who has large holdings of studio ceramics dating back more than 40 years. Like Derrez, he shares some of his personal interest in collecting, thoughts on the responsibility of the collector, and he seems to be preoccupied with keeping the collection together. This has led him to set up a charitable trust for his collection. These two collectors also are similar in that they are both dedicated to making their collections available to the public through exhibitions. This is crucial, I think, as exhibitions make the works part of the ongoing discourse in their respective fields (jewellery and ceramics) as well as in the general culture. This is something that very much relates to other discussions in this book.

To round off the book, we asked Glenn Adamson to reflect on collecting and to offer some views on its future. As you may remember, Adamson participated in the first discussion on the subject in New York in May 2016, and it seemed apt to conclude this series of discussions – the initial conversation, the seminar, the book – with him.

André Gali
Editor

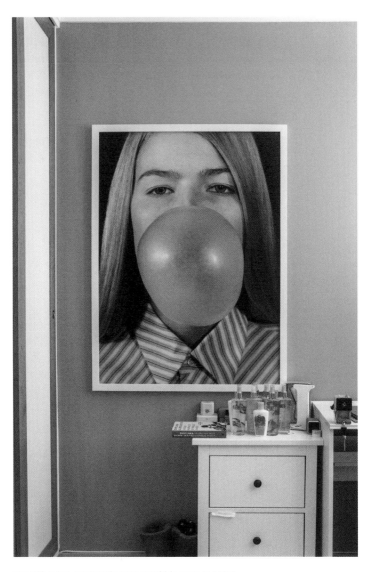

Roe Ethridge: *Louise Blowing a Bubble*. 2011. C-Print.
From Erling Kagge's Collection. Photo: Ina Hagen

The Art of Collecting

Gunnar B. Kvaran

Since ancient times, art has been part of human existence, playing varying roles in different eras, and taking shape in new forms. Over time, individuals have derived pleasure from beautiful things and striven to acquire lavish personal collections. Art museums in the modern sense have only existed since the eighteenth century.

Long before art collecting had started in Europe, the Chinese aristocracy collected works of art, as witnessed by the rich imperial treasures of China. In Europe, the first known cases of individuals setting out to accumulate art collections were in Hellenistic Greece around 2,000 years ago. King Attalus II of Pergamon, who died in 138 BC, is well known for his collection of paintings. In due course, collecting reached Rome, becoming widespread among high-ranking Romans after the conquest of the Greek city of Syracuse in Sicily in 212 BC. The wealthy and high-born of Rome were especially keen to acquire works of Greek art, by whatever means, not caring whether the object was an original or a copy. Roman military leaders were often rewarded for their victories with works of art. Such renowned Romans as the emperors Claudius I, Julius Caesar, Nero and Hadrian, and the military leader Pompey the Great, had magnificent art collections. These were regarded as excessive by many of their contemporaries, who lamented that all these beautiful works of art were hidden away from the public eye in private collections, and proposed that they should be displayed in public squares.

In the middle ages, the Church was the leading collector of works of art, which generally related in one way or another to Christianity. Churchmen did not content themselves simply with paintings and sculptures: they also collected manuscripts, precious and semi-precious stones, holy relics and a range of objects from nature. Monasteries and convents served as treasure-houses for collections of unimaginable value, 'to the glory of God', in the words of the twelfth-century Abbot Suger of St Denis in France, who sought to justify himself and the Church at a time when its worldly magnificence was under attack.

As the Renaissance approached, collectors' attitudes to art changed: they focused on acquiring works of classical Greek and Roman art, which were coming to be seen as the model for perfection in art. At the same time, the makers of the art were emerging from anonymity and beginning to sign their works. Royalty and other wealthy patrons commissioned works on a grand scale from certain artists, who thus gained international fame and fortune. The collectors and patrons of that time are often seen as the forerunners of today's art collectors.

The seventeenth century saw the emergence of a thriving art market. European kings and princes sought to acquire the most grandiose works of art, and their collections often became tangible signifiers of their power and wealth.

By the eighteenth century the rising bourgeoisie were also collecting: prosperous financiers and industrialists, who introduced new principles to collecting. They started to collect some specific type of art, such as drawings or prints – at that time less prestigious than paintings and sculptures. Collectors also became more selective, perhaps electing to focus on a certain genre, such as still life or portraits. Art dealing flourished during that period, especially in London, where both Christie's and Sotheby's opened their first galleries in the late eighteenth century. As art collecting grew, and spread to a wider social spectrum, information about art was shared by collectors: catalogues of private collections were published, and reproductions of renowned works of art became available all over Europe. Collections were categorised and catalogued to professional standards, even at that time. Early in the eighteenth century German art dealer C.F. Neickel published his *Museographia*, the first volume of its kind about methods of classification and conservation of works of art. Later in the century, specialist art-conservation ateliers were opened in Naples, Venice, Bologna, Paris and Dresden.

During the eighteenth century increasingly vocal demands for freedom and democracy were heard, and at that time the old debate was reawakened about lack of public access to art that was hidden away in private collections. One consequence of this development was the presentation of the Medici art collection to the people of Tuscany in 1743 by Anna Maria Luisa, the last of the Medicis. At about the same time the Empress Maria Theresa in Vienna opened her collection to the public, and around 1750 King Louis XV of France felt compelled to open his art collection to the public two days a week at the Palais

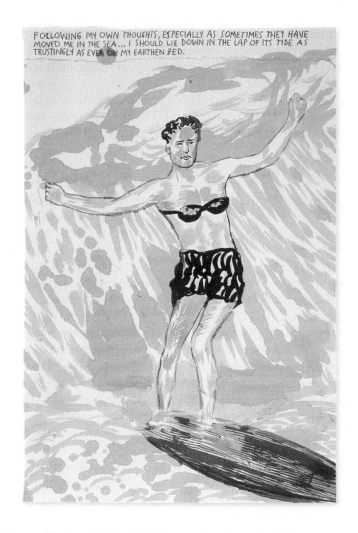

Raymond Pettibon: *No Title (Following my own)*. 1998. Pencil and ink on paper.
From Erling Kagge's Collection. Photo: Regen Projects, Los Angeles

du Luxembourg in Paris. Following the French Revolution of 1789, the royal collections were expropriated by the revolutionary government, and in 1793 the former royal palace of the Louvre in Paris was thrown open to the people as the first public art museum in Europe, heralding a new age of state art museums.

As large and impressive public museums were established all over Europe during the nineteenth century, many foresaw that the age of the private collector would come to an end; but history proved them wrong. Private collections would continue to play an important role in art history, challenging the 'standardised taste' of conservative public art museums and academies. The avant-garde art of the period – Impressionism, Expressionism, Cubism and so on – was excluded from such public art institutions. But the originality and freshness of such art was seized upon by individuals – the collectors. Hence it was often not until an artist had gained widespread acceptance that the public art galleries changed their minds about him. A striking example of this attitude to art in the nineteenth century is the story of French artist Gustave Caillebot, who decided in 1876 to bequeath to the French state the bulk of his personal collection – sixty-seven paintings, among them masterpieces by leading Impressionists. A condition of the bequest was that the works should not 'go to an attic or a provincial museum but rather to the Luxembourg and later the Louvre'. When the bequest came into effect in 1895, the French government strenuously attempted to evade the terms of the will, and ultimately agreed to take into its keeping just thirty-eight of the sixty-seven works. Directors of French art museums clutch their heads in mortification even today when this sensitive subject comes up.

In the late nineteenth and early twentieth centuries private collectors were the clear leaders in the backing of avant-garde art. Such collectors were the first to support and defend the artists who were keenest to change the concept of art and create a new and innovative perspective on reality. Thus they played a part in the rethinking of received ideas of what constitutes art.

In the twentieth century there have been many important private collections. Most of the time, private collectors of modern and contemporary art held their art inside their own walls, but often they had a generous relationship with different public museums, to whom they would donate or lend their works. This is still the case, but in recent years there has been an increasing desire among private collectors to

build and establish their own museums that can rival not only other private collections but also public museums in terms of acquisitions, exhibition making and the knowledge production around contemporary art in general. In fact, private collectors are now more than ever preoccupied with telling their own story of contemporary art. Today, we have an interesting polyphony of voices that are creating diverse micro-narratives about international contemporary art in a variety of formats, scales and structures, and eventually offering a variety of meanings for contemporary art. Some of the best known private collections of contemporary art that have been turned into a museum in recent times are the Astrup Fearnley Museet in Oslo with the collection of Hans Rasmus Astrup, La Fondation Cartier in Paris, the Goetz collection in Munich, Joannes Dakis Foundation in Athens, The Brant Foundation of Peter Brand outside New York and The Eli and Edythe Broad Museum at Michigan State University (Eli Broad is now building a new museum in Los Angeles, which will open to the public this autumn). The French collector Francois Pinault has placed his collection in Palazzo Grassi and Punta Della Dogana in Venice and the most recent initiative is by Bernard Arnault with the Fondation Louis Vuitton in Paris.

In recent years, the western notion and language of art has become universal. This means that more and more people from all over the world are collecting contemporary art. However, despite the fact that we have seen an increasing number of art fairs and 'visible collectors' it has been difficult to get a full picture of the international art collecting scene. Since 2012 we have been able to consult an internet site called Larry's List, which is based in Hong Kong and initiated by two young Germans Magnus Resch and Christoph Noe. The latest report from Larry's List is based on twenty-five specialists in twenty different countries who have access to 27,000 sources concerning the art market and the private collector. Articles in the *New York Times* and *Le Monde* reveal some interesting figures: there are around 10,000 collectors with more than a million dollars in their bank accounts in the world, but only about 3,000 are 'visible'. The average private collector is fifty-nine years old and 71% are men. Most private collectors are in the USA (25%) followed by Germany (8%), Britain (7%) and China (7%). The 'emerging powers' of China, India and Brazil are home to 15% of contemporary art collectors. The cities with the most important number of private collectors are New York (9%), London (6%) and São Paulo

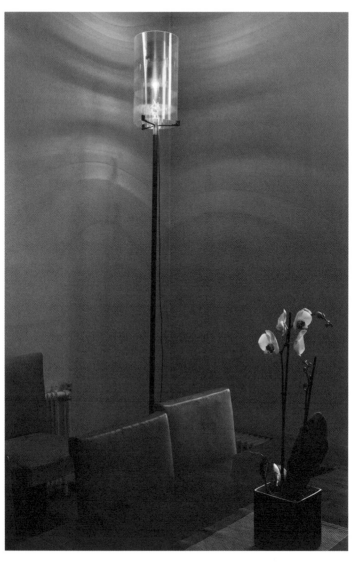

Olafur Eliasson: *Striped eye lamp*. 2005. Sculpture installation in an edition of 10 pieces. From Erling Kagge's Collection. Photo: Vegard Kleven

(3%). According to the report, the number of private art museums has hugely increased in recent years, with 350 private museums in forty-six countries. Again the USA is the leader, with forty-eight institutions. Germany has forty-five and China has seventeen, with six of them in Beijing. All the analysts agree that the Chinese will come to dominate the international art market with their collectors and probably also with their artists in the years to come.

What is a collector? And in particular, what is a collector of contemporary art? Many qualities seem common to collectors, whether the collection is of shells, stamps, butterflies or artworks. Some approaches emphasise the subjective value attached to the object, while others emphasise the importance of the accumulation and selection process. However, collectors who support art 'in the making' stand out as those who are participating with artists and the art scene and who are capable of 'acting' on the arts and contributing to the vitality of the art scene, particularly through material support, as well as contributing to the construction of artistic value.

Norway has had many outstanding art collectors. Historically speaking, the best known are undoubtedly Christian Langaard, Jørgen Breder Stang, Rasmus Meyer, Rolf Stenersen and Sonja Henie/Niels Onstad, who established the Henie-Onstad Kunstsenter. All of them enjoyed the friendship and respect of artists, and they were generous patrons. In recent years the number of private collectors and corporate collections in Norway has considerably increased, most of them with a clear interest in international contemporary art. The best known of these are: Hans Rasmus Astrup, whose collection is housed at the Astrup Fearnley Museet, Christian Bjelland, Stein Erik Hagen, Rolf Arebø Hoff, Erling Kagge, Petter Olsen, Christian Ringnes, Petter Stordalen, Christen Sveaas and Morten Viskum. An increasing number of corporations have developed their own collections of contemporary art, such as DnB NOR, Sparebankstiftelsen, Hydro, Statoil, Telenor and Nordea to name just a few. However, there has been little research and discussion in Norway about the private art collectors and their relationship with the art world. People are familiar with the public art museums, the commercial galleries, the art schools and the critics, but they have had difficulty in placing the art collectors into that equation. Their role and responsibility in art history has not been widely understood or recognised.

For this reason, the Astrup Fearnley Museet, which houses one of the most important private collections of contemporary art in Europe, has chosen to organise an exhibition of works from the private collection of Erling Kagge. It was in the early 1980s that Kagge acquired his first artwork, marking the beginning of what later grew into a spectacular collection. The Kagge collection is remarkably well-composed, each work having been chosen with unusual insight and personal judgement. The post-conceptual works have attracted particular attention in recent years from both experts and art lovers. Most of these are of the highest quality, bearing witness to Kagge's original perspective on international contemporary art, which has formed a subjective one-man collection. But if one tries to define or characterise the Kagge's collection one can find certain constants. He has a tendency to collect works by individual artists in depth, mostly international post-conceptual artists who have emerged in the last ten to twenty years.

Art collecting is a passion. The collector finds a work of art, falls in love with it, and cannot let go of it. And that process repeats itself again and again. The role of the collector in western culture is complex. He explores art history in his own way, picking and choosing, taking a stance. Like the artist, the collector is his own person. It is his personal taste that determines the selection. For this reason, private collections are often far more consistent than public collections tend to be – since their decisions on acquisitions are made by committees, whose disparate views have to be reconciled. It has also been demonstrated that collectors can allow themselves to be bolder with respect to avant-garde art. Thus they tend to be closer to progressive artists and take part in the discovery of new artists. A deep understanding and a rare confidential relationship may develop between artist and collector. The strength of the collector – financial and moral – can therefore be crucial.

At all periods, private collections have been opened to the public, and hence they have had a considerable influence on the perceived cultural, artistic and financial value of the art. In addition, such private collections are the source of many of the works of art now in public collections – where they are perceived as a more-or-less inseparable part of the culture of the nation in question, almost like a law of nature. (In Norway, for instance, we have such examples as the art works offered by Rasmus Meyer to the City of Bergen, Amaldus Nielsen's collection and Ludvig O. Ravensberg's collection to the City of Oslo, Rolf Steners-

en's collection to the City of Oslo and to the City Art Museum of Bergen, and the Christian Langaard collection to the National Museum). So it is no exaggeration to maintain that over the centuries the judgement of a handful of people has had a formative influence on public opinion about objects of art and heritage, offering a yardstick of good taste. Hence we can say that the collector is a creator, whose discovery, selection and arrangements of works is itself a work of art.

This text was first published by the Astrup Fearnley Museum as part of the catalogue for the exhibition *Love Story – Works from Erling Kagge's Collection* at the Astrup Fearnley Museum, 22.05.2015 – 27.09.2015.

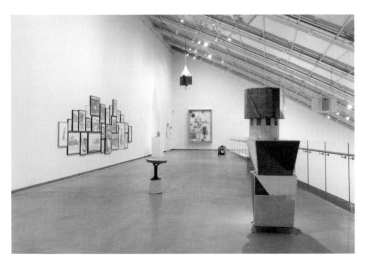

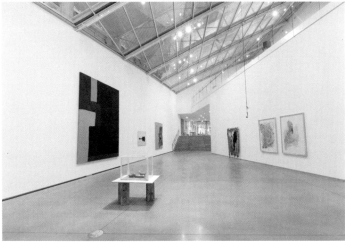

Exhibition view from *Love Story – Works from Erling Kagge's Collection* at the Astrup Fearnley Museum 22.05.–27.09.2015. Photo: Christian Øen

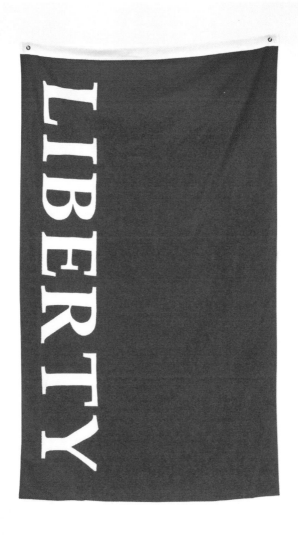

Gardar Eide Einarsson: *Liberty*. 2007. From Erling Kagge's Collection.
Photo: STANDARD (OSLO)

Why Do We Collect?

Margaret Wasz

What prompts us to become attached to inanimate objects? Why do they satisfy us emotionally? And why do we want our collections to grow and endure? These questions impinge upon both the bright and the dark sides of collecting. From my perspective, collecting probably starts with seeing something and forming an attachment to it. I think it starts with looking. But where in us do we become attached to the things we then want to own, collect or keep? And how does all this relate to collecting art? This constellation of questions and ideas provides the basis for this essay.

Early collectors

Our fascination with collecting starts as infants. We start collecting very early. Anyone who has experience with children will see how they become very attached to objects. This attachment can grow into having more and more and more. Children can collect marbles, Barbie dolls, lots of toys and other things. Many emotional needs are being met by owning all these objects. The fascination for collecting therefore starts very early.

We must give a little nod here to Sigmund Freud, who theorised the *object of desire*. For Freud, everything goes back to what he called the anal stage, and he conjectured that we lose something as a child and are continually try to fill that gap, that lack. We are constantly losing and constantly trying to replace. It is an object of desire. We see something, we desire it, get it and it fulfils us, but only for a short time, says Freud. We then need something else that can fulfil that need, again and again and again. He would say it is a continual need to fulfil the unfulfilled, or the lack.

A child learns to feel comfort and emotional security in an inanimate object. A positive relationship begins to emerge, and this is the beginning of the notion of collecting. We feel a really positive connection and want to feel it again and again and again. The sense of ownership and control is therefore facilitated through the possession

of things: if I have them, I own and control them, and this in some way helps me control how I feel.

Not any object will do

Children believe that in addition to the physical properties of their objects, there is some other quality in them that cannot be copied. Professor Bruce Hood likens this to art enthusiasts: we do not want a copy; we want the original. What happens, he says, is that we actually 'anthropomorphise objects – look at them as if they have feelings'.[1] We project something of ourselves onto the object, and that creates an essence; it is the intangible thing we create with the other or the object.

As stated, when we see a work of art, we want the original. Hood did an interesting experiment: he showed two boxes to small children who had with them their object of desire, for instance a teddy bear. He said: 'You can put your teddy in this box, and in the other box, we will replicate – make an identical copy – of your little teddy bear.' 22 children were involved. Four completely refused to give up their object. Of those who did give up their object, only five would take the reproduction. Now, they were all told at the end of the experiment that they had actually gotten their original object back. But the idea here is that we do not want a copy. The teddy bear is like art: we do not want a copy, we want the thing we have anthropomorphised. We have given something of ourselves to it, and through that activity, we create contact and establish a relationship with the object.

A psychoanalytical perspective

In the book *Collecting: An Unruly Passion,* Werner Muensterberger discusses the idea of excessive collecting being rooted in neurotic, fetishist, compulsive or obsessional desire.[2] We may feel confronted by this idea and respond with denial: 'I'm not neurotic, I'm not obsessional.' But I suppose in some ways we certainly can be neurotic, obsessional and compulsive. I think it is important not to be afraid of this side of ourselves. It is when collecting crosses the proverbial red line that it

1 Bruce M. Hood & Paul Bloom: Children Prefer Certain Individuals over Perfect Duplicates, *Science Direct Cognition, 106*(1), (2008) 455–462.
2 Werner Muensterberger: *Collecting: An Unruly Passion: Psychological Perspectives* (New York: Harcourt, Brace & Company, 1994). See https://muse.jhu.edu/article/26823 for a review.

becomes a problem. Collecting *can* be obsessional. I know from my own experience that when I want something, I become a bit neurotic about getting it.

From an analytic perspective, one would say collecting is a compensation for prior disappointment and an illusory comfort in the face of uncertainty. The starting position here is that we are always disappointed, that there is always something in our blueprint that has created this sense of lack or disappointment or uncertainty. And because objects are much more dependable than people, objects will give us much more than a person can, for another person may also have the same sense of lack as we have. We very rarely collect people. We collect objects. My point is that we collect objects because they are reliable; we can return to them again and again. This is why beautiful pieces of art – we go to see them over and over again, and each time they fulfil us. But only for a short time, unfortunately. It is rare for a thing to fulfil you forever. If you find that, you are very lucky.

The repetitive nature of collecting allows for recurring feelings of ease and satisfaction to be repeated with each new acquisition. I think we can probably all identify with this: 'I'll just buy this one and I'll be happy forever!' And then you buy it. And then you see another thing and say 'I'll just buy this and I'll be happy forever!' And the pattern repeats, on and on and on. Some people do not want to own the thing, but many do. It is not necessarily that you want to own it, but you want to repeat the experience. And that experience is how you connect with it.

As Muensterberger puts it, 'the acquisitive bent of the collector is derivative of the 'grasping and clinging' of the infant'.[3] There is this repeated grasping and clinging, grasping and clinging:

> The true significance [of collecting] lies in the, as it were, momentary undoing of frustrating neediness but is felt as an experience of omnipotence. Like hunger, which must be sated, the obtainment of one more object does not bring an end to the longing. Instead, it is the recurrence of the experience that explains the collector's mental attitude. The compelling concern to go in search, to discover, to add to one's store, or holding, or harem, is not generated by conscious planning. Rather, every new addition, whether found, given, bought, discovered, or even stolen, bears the stamp of promise and magical compensation.[4]

3 Werner Muensterberger: *Collecting,* 18–19.
4 Werner Muensterberger: *Collecting,* 13.

I think there is truth in this, in the sense that we are not born to be satisfied. We are emerging all the time; there is something in us that is always looking and searching. I have never met a fully satisfied person. This is not to say that such people do not exist; they simply do not exist in my world. So what I point to here is the idea of looking and searching, of always being on that quest.

A phenomenological psychological perspective

Collecting is a subjective experience. It is not objective. It is very much 'you'. In phenomenological psychology, the experience is 'in-relation-to' the phenomenon or object. Let me elucidate this in relation to a work of art: you create a relationship with it, you direct yourself towards it. It is defined by qualities of *directedness*, *embodiment*, and of *being-in-the world with the work* (*worldliness*). Directedness is the idea of there being me and the object, and what is created is a third thing. The interrelatedness is key: how I come to the object, my essence and the essence of the object, and what happens in the relationship and how the two connect, creates something else, a third sense.

The idea of embodiment is that you can embody the essence of an object or thing. In this experience, you come to it and you embody it in some way. Some of the essence of that object is embodied in you. That embodiment is fulfilling. Now, you can embody in a negative way as well. That can be fulfilling for some people – it depends on where you are coming from. But embodiment is not necessarily always a positive feeling. When some people collect, they enter into the 'darker side' of collecting, which is actually a very negative experience. I will say more about that shortly, but first, let us look a bit at motivation.

What motivates us to collect?

The interesting thing about collecting is that people collect everything! Absolutely everything! It is extraordinary what people collect. There are several motivating factors.

Power and prestige

Early *cabinets of curiosities,* while providing a solace and retreat for contemplation, also served to demonstrate magnificence and power in the symbolic arrangement of their display. A 'cabinet' was, in part, a symbolic display of the collector's power and wealth. We feel a need to express power and prestige. This is the case on an individual level but

also on an institutional level: museums like to acquire new works, and with an acquisition comes a sense of prestige related to owning the new piece. Now, a lot of people do not like the idea that they are motivated by the desire for power and prestige. Nevertheless, it can exist in us.

Investment

Interestingly enough, very few people collect to invest. I recall a silver dollar that was minted in 1794, which many experts believe was the first such coin struck by the U.S. Mint. It sold for $10 million. A good investment! I think we all would invest if we knew we would get that sort of return. But most collectors do not really want to sell on.

Passion and taste

Passion and taste form another motivation. One thinks of Yves Saint Laurent and Pierre Berge's art and furniture collection. Robert Murphy, an author and antiques dealer, says their collection was 'testament to two of the greatest tastemakers of our time. [It] leaves us the key to unlock a rare union of passion, taste and supreme connoisseurship'.[5]

We cannot underestimate the idea of passion in combination with collecting. People develop a huge passion for something. But passion is difficult. So we channel it through collections and the like. You find you have a passion for something. But passion also needs to be fed, it is like a monster. Passion does not always die, it can grow. When you feed the passion, the more passionate you become.

Fun

People collect all kinds of things simply for the fun of it. For instance there was this man who collected beer cans. He collected thousands upon thousands of them. He was married, and he and his wife had to buy a bigger house in order to accommodate his beer cans. He had all the rooms thermostatically controlled. (All the cans are empty, by the way.) But there came a point when his wife said: 'Now look, it's me, or the beer cans!' He chose the beer cans. So that is passion for you. But it does also involve fun. It enables collectors to expand their social lives, attend swap meetings and exchange information with like-minded people.

5 Robert Murphy & Ivan Terestchenko: *The Private World of Yves Saint Laurent and Pierre Berge* (London: Thames and Hudson, 2009).

Preserve the past

Collections are used to understand the ways in which objects embody worldviews and indigenous forms of knowledge, as well as how their creation and use are enmeshed in social relationships. Social connection is a very important part of collecting because, as stated, we meet like-minded people. It is a way of communicating, a means of expression, a common denominator, it is the unsaid. After all, language is limited. Yet through our collections, through art or whatever it is we collect, we have an immediate inroad into another person.

Altruism

You have probably all heard of Herb and Dorothy Vogel. They amassed a collection of over 4,782 works of art. They displayed some works but stored others in cupboards and under the bed, in their rent-controlled one-bedroom apartment on Manhattan's Upper East Side. In 1992 they decided to transfer their entire collection to the National Gallery of Art in Washington D.C. Their reasoning was that the museum charges no admission and does not sell donated works. They wanted their art to belong to the public. This is true altruism, and rare.

Endowment

The *endowment effect* is the hypothesis that people ascribe much more value to things merely because they own them.[6] I am reminded of Gollum, in J.R.R. Tolkien's novel *The Hobbit*, who has a ring he lovingly calls 'My Precious'. By owning it, something is created in the psyche that is very different from the condition of *not* owning the object. The endowment effect creates a sense of security: 'It's mine.' And this security can create peace of mind.

The thrill of the chase

The psychologist Rebecca Spelman describes collectors as deriving 'great enjoyment from applying their thoughts and energies into tracking items down and then, when they are successful, it gives them a

6 Richard H. Thaler: Toward a Positive Theory of Consumer Choice. *Journal of Economic Behaviour and Organization*, *1*(1), (March 1980), 39–60.

thrill. The pleasure-seeking sensors in the brain light up and then they want to experience that again, and so a new search begins.'[7]

The limbic system in our brain lights up and, for anything that gives us pleasure, we rarely say 'I'll never do that again'. If something is pleasurable, we want to do it again. There is something in that thrill of acquiring and looking and searching, and then we get it, and it is a great feeling, but it does not last very long, which seems a shame.

When collecting becomes pathology

The dark side of collecting emerges when the practice turns into the psychopathological form described as hoarding.[8] The 'abnormality' of the hoarder shows up in instances where the aberrant behaviour interferes with an otherwise 'reasonable life'. This can sometimes include gross interference with the lives of others, even leading to law-enforcement issues. An example would be when one person imprisons another person or persons, to satisfy some need. There have been cases of this in the media in the last few years. One also thinks of those who collect an excessive number of cats or dogs: they may think they are doing the animals a great favour, but in fact it can be pathology.

Steven W. Anderson, a neurologist who studies hoarding behaviour, posits that the need to collect stems from a basic drive to procure basic supplies such as food.[9] It starts with the hunter-gatherer deciding what and what not to keep. This drive originates in the subcortical and limbic portions of the brain, and according to Anderson, we use the prefrontal cortex to determine which supplies are worth saving (or hoarding). This part of our brain – the prefrontal cortex and limbic system – when functioning well, helps us collect to a healthy degree. If there is damage to the prefrontal cortex, we can develop into hoarders, unable to let go of things.

Compulsive acquiring can be considered an impulse control disorder and indicates pathology in the prefrontal cortex and amygdala

7 Rebecca Spelman, quoted in Rachel Halliwell: Why do we love to collect? *The Telegraph* (31 October 2014). http://www.telegraph.co.uk/sponsored/finance/personal-economy/11182739/why-do-we-collect-things.html

8 Gail Steketee & Randy O. Frost: *Compulsive Hoarding and Acquiring: Therapist Guide.* (Oxford: Oxford University Press, 2007).

9 Steven W. Anderson, Hanna Damasio & Antonia R Damasio: A Neural Basis for Collecting in Humans, *Brain* 128 (2005) 201–212.

as well as the septum. The septum is the emotional and stimulus gate and contains the pleasure centres.[10] Now we all have this, and it is not always damaged. So compulsive acquiring can occur even when the brain is completely healthy, for it concerns fulfilling the unfulfilled. This is the idea that a certain object will fulfil a need, and I will in some way become more complete once I have it. Oftentimes compulsive collecting is done to alter negative mood states, decrease anxiety or relieve tension, and it can be treated similarly to other addictive behaviour.

Trophy collectors

In the past, corpse mutilation and the warrior's practice of collecting body parts as trophies were believed to be caused by the stress and rigors of war. The shock of war was believed to be the motivating factor for this grisly type of behaviour. New studies, however, are beginning to show that *racism*, and not psychological disorders, was the motivator for such collecting. To collect body parts as trophies engenders feelings of domination, power and omnipotence. Racism enables people to differentiate themselves from those they fight against, to dehumanise and consider the enemy as utterly different.[11]

It is not uncommon to hear of murderers collecting trophies from their victims. Psychologists theorise that this probably has to do with killers wanting to prolong the thrill of their exploits. In much the same way as one collects in a healthy way and prolongs the pleasurable sensation, so also when collecting is pathologised: one seeks to prolong the thrill. By taking a small memento, one is reminded of the crime and able to re-live it as a fantasy again and again. For murderers, these souvenirs are indicative of a great accomplishment, much like others collect mementos to remind them of their academic or other achievements.

10 John D. Preston, John H. O'Neal & Mary C. Talaga: *Handbook of Clinical Psychopharmacology for Therapists* (Oakland, CA: New Harbinger Publications, 2005), 37.
11 Simon Harrison *Dark Trophies: Hunting and the Enemy Body in Modern War* (New York/Oxford: Berghahn Books, 2014).

Why we collect art

Erin Thompson, assistant professor of art crime at John Jay College of Criminal Justice, offers insight into why people collect art: 'The Roman rhetorician Quintilian claimed that those who professed to admire what he considered to be the primitive works of the painter Polygnotus were motivated by 'an ostentatious desire to seem persons of superior taste'. Quintilian's view still finds many supporters today.'[12] We say to ourselves: 'I have taste, I know what I'm about. I'm omnipotent, I'm better than you.' Art collecting may therefore have less to do with economic gain and more to do with trying to create and strengthen a social position and social bonds. On this view, art collecting is a means for collectors to communicate information about themselves. It is a way of saying 'This is who I am. My collection tells you a little about me. It allows me to enter into a social milieu that I might otherwise not be able to enter.' It is a means to feel part of something bigger.

The way in which collectors describe their first purchases often reveals the central role of the social element. It is the social encounter that sparks interest. Only very rarely do collectors attribute their collecting to a solo encounter with an artwork, or curiosity about the past, or the reading of a textual source. Instead, they almost uniformly give credit to a friend or family member for sparking their interest, usually through encountering and discussing a specific artwork together.

Art is a powerful way for artists to express thoughts and feelings – but collectors know that art can also serve as an expressive vehicle for themselves. An artist creates a work and it is an expression of the artist, but when the collector collects it, it becomes an expression of the collector. Here is more insight from Thompson:

> From the beginning of art-making, we have believed that artworks capture and preserve the essence of their makers and even their owners. As identity can derive from lineage, owning artworks is therefore also a way for an owner to communicate with the past. In art collecting, the past is usually about the collector's perceived affiliations with notable people.[13]

12 Erin Thompson: Why People Collect Art, *Aeon* (23 August 2016). https://aeon. co/essays/what-drives-art-collectors-to-buy-and-display-their-finds. See also Erin Thompson: *Possession: The Curious History of Private Collectors* (New Haven: Yale, 2016).

13 Erin Thompson: Why People Collect Art.

To this, we can add a thought from Freud: 'A collection to which nothing can be added and from which nothing can be removed is, in fact, dead.'[14]

Is collecting art therapeutic?

The Russian author Leo Tolstoy saw art as therapeutic. Art was a way of dealing with emotions. Acquisitions provide a bridge of empathy between us and others. For the French author Anaïs Nin, it is a way to exorcise our emotional state. But might not art and its acquisition be 'something that reconciles the two: a channel of empathy into our own psychology that lets us both exorcise and better understand our emotions – in other words, a form of therapy?' asks Maria Popova.[15] Art collectors are artists in their own right, by how they combine things. As the collector Peter Ayers Tarantino says: 'You can read a person's soul from their collection.'[16]

For anyone who buys anything: I think it does fulfil a need. It is pleasure oriented, but other motivational factors are usually also involved, four or five perhaps. Ultimately, however, collecting does fulfil us in some way. And collecting art is not a bad way to be fulfilled.

14 Sigmund Freud, quoted in Robert Neuberger: Arman l'Africain, *Art Tribal* (Spring 2003).
15 Maria Popova: *Brain Pickings* internet magazine. hhttps://www.brainpickings.org/2013/10/25
Popova discusses Alain de Bottom & John Armstrong: *Art As Therapy* (London: Phaidon, 2013).
16 Peter Ayers Tarantino, quoted in Joscelyn Godwin: The Wonder Years, *Art and Antiques,* (December 2008).

MIMA, visitors session in the depot 1.
Photo: Middlesbrough Institute of Modern Art

The Life of Jewellery in Museum Collections: The Netherlands, a Case Study

Liesbeth den Besten

Through many years of studying jewellery, I have become increasingly aware of the unfavourable position of jewellery in museum collections. Jewellery is only a small part of the applied arts and design and of the visual arts in general, but it serves as a good example of museum policies because of its specific characteristics.

In this article, I use my own country as a case study to analyse how museums deal with jewellery collections, also presenting examples from other countries for the sake of comparison or to support my arguments. I preface the predicaments of jewellery in museum collections by first reviewing the status of private jewellery collectors and how their expertise renders their collections desirable as acquisitions for museums. I then present what I have called the 'hidden life' of jewellery in museums. This points to the jewellery acquisitions being 'kissed asleep' in the museum depot, but also to a constellation of other problems contributing to jewellery's unstable status in museum collections. The paper closes with discussing the future prospects for jewellery in Dutch museums and the need for a specialised museum that can ensure the study and presentation of jewellery's important history and use in society and in art.

The expertise of private jewellery collectors

In general, curators who work in museums for the applied arts and who have a mandate to collect jewellery, also collect design objects, ceramics, glass and textiles. Their specialisation in a specific field of craft is uncommon. At the same time, a lot of jewellery collecting is done by others. As a matter of fact, the number of people who collect jewellery for private reasons far exceeds the number of professional collectors. Starting out as a consumer, a buyer can develop into a

collector. When one's collecting practice matures, a sense of responsibility arises, and then being sure to provide good storage and documentation become part of the collecting activity. Private jewellery collectors invent creative ways of dealing with their collections: many are dedicated wearers who like to share their experience with others; some design special displays or cases in their house to show the jewellery. Every such strategy reflects an intense interaction between a collecting subject and his or her objects, incited by the nature of jewellery.

Many private collectors have a collection plan and know the exact criteria according to which they collect, for instance: finger rings, necklaces, jewellery from non-precious materials, Dutch geometric jewellery in metals and synthetic materials from the period 1960–1990, jewellery and jewellery-related work with a conceptual focus, contemporary and ethnological jewellery, contemporary and regional jewellery. Some collectors focus on following specific artists throughout their career. These examples of collecting criteria are found amongst collectors in the Netherlands, and they show that private collectors, rather than simply accumulating, are relying on their knowledge and intuition.

Museums claim to have authority and knowledge, but we might ask whether this claim is still tenable today. Especially in a small but global field such as contemporary jewellery, it is no longer as a matter of course that the greatest connoisseurship is inside the museum; it could be outside, with the private collectors. They are well informed and unhindered by official restrictions, thus able to visit more exhibitions than could any professional curator. Sometimes they have an abundance of time and money.

Private collections go public

For the reasons I have just outlined, it is understandable that museums are interested in acquiring private jewellery collections. In the last decade we have seen a growing number of private collections ending up in museums, supported by regulations that make endowing profitable, especially when the donor is well to do. It was only about 25 years ago that museums started acquiring extended private contemporary jewellery collections. One of the first was the Montreal Museum of Decorative Arts' acquisition in 1993 of a collection of American studio jewellery from the period 1940–1960, assembled by Mark Isaacson, Mark

McDonald and Ralph Cutler.[1] On the back cover of the book published in connection with this acquisition, there is an interesting statement from an 'eyewitness' of this kind of jewellery:

> About 1947 I bought a pin ... because it looked great, I could afford it and it identified me with the group of my choice – aesthetically aware, intellectually inclined and politically progressive. That pin was our badge and we wore it proudly. It celebrated the hand of the artist rather than the market value of the material. Diamonds were the badge of the philistine.[2]

This prominently-presented statement points to the social significance of jewellery – an aspect generally overlooked in art museums. In 2002 the Museum of Fine Arts in Houston acquired Helen Drutt's collection of 800 pieces of jewellery. This event was talked about and treated in a different way: the additional classifiers 'art' and 'avant-garde' opened the doors of a fine arts museum, the MFA in Houston, which up to that point had no real jewellery-collecting policy. The accompanying traveling exhibition[3] had a strong focus on two-dimensional works (sketches and drawings), while necklaces and other wearable pieces were mounted in wall frames. In 2014 a curator at the Metropolitan Museum in New York decided to exhibit a selection of jewellery from the recently acquired Donna Schneier collection; she hung the works freely suspended in showcases, drawing viewers' attention to the back side of jewellery pieces.[4] These examples present three different approaches to interpreting jewellery collections, all of which are valuable: jewellery as a social token, a signifier; jewellery as art; jewellery as an aesthetic object that has specific characteristics because it should be worn (ingenious fastenings and wearing constructions, elaborated backs, etc.).

1 They were partners in Fifty/50 Gallery in New York City. Founded in 1982, it focused on mid-century design.

2 Martin Edelberg (ed.): *Messengers of Modernism: American Studio Jewelry 1940–1960*, Montreal Museum of Decorative Arts (Paris, New York: Flammarion, 1996).

3 The exhibition *Ornament as Art: Avant-Garde Jewelry from the Helen Williams Drutt Collection*, Museum of Fine Arts Houston 2007, and travelling in 2008–2009 (Renwick Gallery, Washington DC; Mint Museum of Craft, Charlotte, NC; Tacoma Museum of Art, Tacoma, WA).

4 Suzanne Ramljak: *Unique by Design: Contemporary Jewelry in the Donna Schneier Collection* (New York: The Metropolitan Museum of Art, 2014).

Also in Europe, large collections are being given to museums (or are in the process). The Swiss National Museum in Zurich recently accepted as a permanent loan the Alice and Louis Koch collection of over 2,500 rings.[5] The history of this special collection goes back to the early Twentieth Century, by which time Alice and Louis Koch had already amassed some 2,000 rings in Frankfurt where they lived. Forced by the situation in pre-World War II Germany, they moved to Basel and established the Alice and Louis Koch Foundation, eventually extending the collection by adding over 500 rings made by contemporary artists. In the Netherlands, the Rijksmuseum (the Dutch National Museum in Amsterdam), acquired the Marjan and Gerard Unger collection of 500 pieces of Twentieth-Century Dutch jewellery.[6] As of today, this is the only successful donation of an extensive private jewellery collection to a public institution in the Netherlands; attempts by other collectors have failed, probably not due to a lack of interest from the museums, but due to a lack of funding and staff.

Transitions from the private to the public realm require a long negotiation period. First of all, a museum needs to assess the historical and cultural significance of the proposed gift and how it can be integrated with the museum's existing collections. But there can be friction between the expectations of the donor, who wants to gift his/her collection as a whole, and the museum, which may want only to pick the best pieces. Furthermore, the acquisition of hundreds of works all at once presupposes a well-equipped museum with ample staffing.

In the United States, recent acquisitions of jewellery collections have been accompanied by exhibitions and catalogues. Research teams are formed, sometimes involving researchers from outside. One example of this is in Dallas, where external scholars have been recruited to do research on the Viennese gallerist Inge Asenbaum's collection of more than 700 works from the 1960s to the end of the Twentieth Century. This collection, featuring works by many Central Euro-

5 The acquisition was announced in a press release by the museum, 30 July 2015.
6 A small selection of the collection is integrated into the historic jewellery display at the Special Collections department. Marjan Unger and Suzanne van Leeuwen, a junior curator and conservator at the Rijksmuseum, are currently preparing a publication about the museum's historical and Twentieth-Century jewellery collections.

pean artists, was brought together by the art dealer and gallerist Inge Asenbaum and acquired by Deedie Potter Rose, a philanthropist and long-time supporter of the Dallas Museum of Art. Rose then donated it to the Dallas Museum of Art.[7] She also intends to fund the research, which is an ideal situation. It goes without saying that research, publications, data-bases, exhibitions and seminars are good for the donor, the museum, and, not least, for jewellery.

The largely hidden and difficult life of jewellery in museum collections

In the long term – after the festive induction – there is a danger that many of the jewellery collections which museums have acquired will be 'kissed asleep' in the museum's depot. One thing is certainly clear: with the new trend of integrated displays in museums, private jewellery collections become dispersed. In the MFA in Boston, only a few pieces of jewellery from the Farago collection are exhibited in the integrated applied arts department. Helen Drutt's collection in Houston, and Donna Schneier's collection in the MET are now kept in the depot. An encyclopaedic museum of fine art is not a museum of decorative arts, and its mandate is different as well. However, the acquisition of a private jewellery collection can also be the start of a new museum strategy. Cindi Strauss, curator of decorative arts, craft, and design at the MFA in Houston, who did all the research involved in the Drutt collection acquisition process, has become a connoisseur. Strauss possesses exhaustive knowledge of the Drutt collection as well as of the other jewellery works in the museum's holdings, and she is the best person to take care of jewellery in an integrated and inter-departmental presentation. Yet within such a configuration, there is only room for a few pieces of jewellery: one showcase with one to five works in the decorative arts department, and another showcase in a temporary interdepartmental exhibition.[8] Jewellery is indisputably

7 Press release of the MFA Houston, 1 May 2015.
8 The display of American decorative arts and craft from the late Nineteenth Century to present (with one case for jewellery) changes every six months. The jewellery is drawn both from the Drutt collection and the museum's other jewellery collection. Jewellery is also integrated into temporary exhibitions. I thank Cindi Strauss (e-mail 22 November 2016) for this information.

taken seriously as art, but there is not much room for jewellery as jewellery, meaning an aesthetic, wearable object that gains meaning in the wearing and because of the wearer.

Regrettably, there are very few museums of applied art compared with museums of fine art and encyclopaedic museums. Museums such as the Victoria & Albert in London or the Musée des Arts Décoratifs in Paris are exceptional. In my country there is not even one museum for applied art and design. On the other hand, many of the Dutch museums have applied arts collections. Of these, at least eleven have jewellery collections or the inherited collections of an individual jewellery artist – but only four show some jewellery activity.[9] In the other museums, jewellery is stored away or orphaned because there is no specialised curator. After all, jewellery is quiet and does not take up much space in a storage facility.

The CODA Museum in Apeldoorn holds the largest collection of contemporary jewellery in the Netherlands, 6,500 pieces, built around what the museum calls 'principal artists' and sub-themes.[10] At the moment, CODA is the only Dutch museum where jewellery exhibitions are constantly being organised.[11] In 2016 it opened a new display for the permanent collection, but sad to say, it only presents a very small part of the collection. Although the amount of temporary exhibitions and the average quality of these is laudable, the example of this museum also reveals some weaknesses: up till now its strategy has been dependent on one person, the museum's director, while there is no curator. Furthermore, the museum is dependent on local money supplemented by occasional gifts and grants. Its jewellery exhibition strategy therefore does not appear to be a sustainable structure.

9 Rijksmuseum Amsterdam, Stedelijk Museum Amsterdam, CODA Apeldoorn, Museum Arnhem, Gemeentemuseum Den Haag, Zuiderzeemuseum Enkhuizen, De Lakenhal Leiden, Het Valkhof Nijmegen, Boijmans van Beuningen Rotterdam, Textielmuseum Tilburg, Centraal Museum Utrecht.

10 Carin Reinders: *Re/Defining Jewellery, Sieradencollectie CODA Museum* (Apeldoorn: CODA, 2016).

11 In the period 2015–2016 there were exhibitions about Felieke van der Leest, GEM Kingdom, Barbara Paganin, Nicolaas Thuys, Paul Derrez, Sophie Hanagarth and Evert Nijland. The exhibition *Private Confessions* featured drawings by jewellery artists. Exhibitions about Lucy Sarneel and Ruudt Peters are planned for 2017. Most exhibitions are either curated by a guest-curator or the artist.

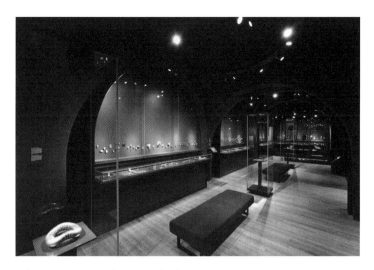

Rijksmuseum Amsterdam, Special Collections.
Photo: René den Engelsman, Rijksmuseum Amsterdam

MIMA, visitors session in the depot 2.
Photo: Middlesbrough Institute of Modern Art

As a matter of fact, the Netherlands has already witnessed how easily such a strategy can collapse when the central figure disappears. In 2009 Yvònne Joris (1950–2013), who had been the director of the Stedelijk Museum 's-Hertogenbosch since 1987, retired. Her final exhibition, *Private Passion: Artists' Jewelry of the 20th Century*, demonstrated her legacy.[12] Over a period of more than 20 years, Joris had built a coherent collection of jewellery and ceramics made by fine artists (Picasso, Anish Kapoor, etc.) and contemporary American and European jewellery artists. She was the one who introduced American jewellery in the Netherlands.[13] While her strategy was based on dedication and understanding, it also had the character of a private passion. Under her successor, René Pingen, the museum followed the same policy to a great extent. But due to Pingen's tragic death in April 2016, only eight years after the retirement of the founder of the collection, the museum passed through its second change of director: once again, its strategy metamorphosed to become more distant from that of the first director. In October 2016 the exhibition *Cult*, curated by Marina Elenskaya and Kellie Rigs from the magazine *Current Obsession*, opened.[14] This is a true event and something to celebrate, but there is some uncertainty about what will happen in the near future. After all, the museum is not a designated museum of applied art, and the new director has no history in this area.

Both CODA and the museum in 's-Hertogenbosch are rather small municipal institutions in medium-sized towns, mostly funded by local money. This, along with the dependence on the private passion of one person, makes the position of these public jewellery collections vulnerable. The Museum Arnhem, which has also had a collection of contemporary jewellery since the 1960s, has gone without a curator for applied arts since October 2015. In 2017 CODA and Museum Arnhem will appoint a shared and part-time jewellery curator for a fixed period

12 Yvònne G.J.M.Joris: *Private Passion: Artists' Jewelry of the 20th Century* (Stuttgart: Arnoldsche, 2009). To my knowledge, this is the only museum in the world that has specialised in collecting jewellery made by fine artists.
13 Exhibition *Beauty Is a Story*, Museum Het Kruithuis 's-Hertogenbosch, 1991.
14 The exhibition was initiated under former director René Pingen (1959–2016).

of four years.[15] Although positive, this news also includes the announcement of the loss of a permanent applied arts curator in Arnhem.

The position of the other applied arts in the Netherlands is much better, with specialised museums for ceramics, glass and textiles. Some museums even have permanent departments and curators for ceramics and glass. By contrast, the position of jewellery in public collections in the Netherlands is rather diffuse: jewellery is simultaneously everywhere (in about eleven museums and museum depots) and nowhere, because it is barely visible.

Problems in combining jewellery
with other forms of art and craft

Good news for jewellery collections came with the re-opening of the Stedelijk Museum in Amsterdam (September 2012) and the re-opening of the Rijksmuseum (April 2013) – after being closed for about ten years almost simultaneously. At the time of the Stedelijk's re-opening, newspapers and magazines wrote laudatory columns about it. The general feeling was that we finally had a museum for modern art *and* applied art and design. One floor in the western wing of the old museum was completely dedicated to applied art and design. The entrance room had a semi-open depot set-up (including jewellery), and the thematic rooms featuring Twentieth-Century design did include jewellery to some extent in the applied arts and design collections. It also provided a jewellery pavilion: not a very magnificent space and limited to six wall showcases, but with the possibility of alternating presentations. Only four years later, the situation changed drastically.

The re-opening of the Rijksmuseum also added to the positive mood. This institution's holdings include important sub-collections of decorative art, fashion, Asian art and national history. For the first time, selections from these collections were permanently displayed, including jewellery and pieces from the Unger collection. Finally jewellery (historical and contemporary) had gained greater visibility in two of the main Dutch museums.

But both presentations also revealed *a major problem of jewellery in a museum context*: when put amidst functional design and graphic

15　The jewellery collection at the Museum Arnhem includes about 800 pieces. The museum had a curator for applied arts in the period 1967–2015, with several interludes between the different curators.

design, contemporary jewellery is out of place, and neither does it fit into the shiny context of the Rijksmuseum's precious jewellery collection. What is lacking in most jewellery displays, not only in the Netherlands, is an understanding of what jewellery is about. The idea that jewellery is strongly related to the person who wears it – the object and subject coincide – is an uncommon perspective in art museums. This is not surprising because such a perspective represents an anthropological view of jewellery.

Exhibition clichés

If jewellery is presented in a museum, it is often done in a clichéd way, especially if the museum has a collection of historic jewellery. The two most important applied art museums, the V&A and the Musée des Arts Décoratifs, prefer a dark and glossy setting behind the door of a safe or another type of security barrier, thus providing a model for jewellery presentations elsewhere in the world. The Danner Rotunda for contemporary jewellery in the Neue Sammlung in Munich (which opened in 2004) is also a gloomy underground space.[16] This model reflects jewellery's fate: that it is supposed to shine and sparkle, be made from exquisite materials and be worn by kings, nobility, rich citizens, and especially women. It therefore needs the atmosphere of a treasure house or a jewellery box. In such a context, the only function of jewellery seems to be its monetary value. True enough, one of jewellery's functions is indeed to act as a placeholder for money, a safe investment (one that is often commented upon by contemporary makers), but jewellery has so much more to offer. Since time immemorial it has been a social intermediary, reflecting alliances, dignity, marital status, subordination, distinction, religious beliefs, protection, loss, political convictions, derision, and more. It has been used in rituals and is integral to the domain of intimacy and touch. However, when perceived in these multifarious ways, jewellery enters the realm of anthropology and sociology, which does not match the strategy of art museums.

16 Thanks to former director Dr. Florian Hufnagl, the museum started collecting contemporary jewellery in the 1990s. Donations from the private collections of Peter Skubic, Sepp Schmölzer and Marianne Schliwinski and Jürgen Eickhoff, and a financial gift from the Danner Foundation led to the building of a permanent jewellery gallery, the Danner Rotunda.

Two pitfalls: Conventional ideas about jewellery and autonomous art jewellery

Conventional thinking about jewellery is rather biased: jewellery is perceived as a female thing (this is absolutely false as every jewellery historian knows) and has no other function than to decorate and show the wealth of the wearer. It is made from shining precious materials and is supplemental. In short: it has little or no significance.

Contemporary jewellery, also called 'art jewellery' or 'author jewellery', is a relatively new branch that suffers under the conventional supposed and superficial character of jewellery. By pretending that jewellery is art, its advocates try to give it a higher status, but by granting jewellery an art status, its isolation is a fact. Contemporary jewellery functions in a different way than historic jewellery, which was much more a part of daily life. One aspect, however, is quite similar: this jewellery is also made for wearing. Its role is to engage with the body and the person wearing it, and to act as a signifier. This connection with people, and with the human scale, is seldom highlighted in art museums. On the contrary, by exhibiting jewellery on a horizontal plane, a distance is created – the jewellery pieces become art objects, miniature sculptures with aesthetical presence, but lacking a meaning related to a wearer. The simple addition of photography in jewellery exhibitions could be revealing. After all, this kind of jewellery is extraordinary and therefore needs more attention and care when being displayed.

Trying to kiss jewellery collections awake

A few museums have recognized the problems of treating jewellery collections as autonomous art and letting them sleep or stay hidden in depots. In 2008 the Museum of Contemporary Craft in Portland (Oregon) organised the exhibition *Touching Warms the Art,* which presented jewellery designed especially for the occasion. Visitors were invited to handle the pieces, try them on and post photos on social media.[17] It was a brave attempt to break contemporary jewellery's isolation. Another example: on the occasion of the construction of a new museum building, the Middlesbrough Institute of Modern Art (MIMA)

17 *Touching Warms the Art*, curated by Rebecca Sheer, Rachelle Thiewes and Namita Gupta Wiggers.

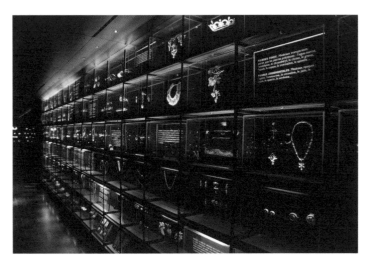

Musee des Arts Decoratifs, Paris, jewellery department

started using contemporary jewellery as a medium to communicate with citizens.[18] Here the curator James Beighton initiated and invigorated a new approach to jewellery-collection care and development. During the run-up to the launch of a jewellery gallery that opened in 2014, the museum offered visitors the opportunity to handle pieces of jewellery during pre-planned sessions. This made MIMA one of the few museums in the world to refrain from security anxieties and let the public character of its collection prevail. In the newly installed jewellery gallery, everything was done to engage the public. Photos, an electronic table for searching through the collections, drawers with a semi-open storage display, the opportunity to take jewellery-selfies, and a film about contemporary jewellery invited visitors to interact with the collection.[19] However, the alert reader may notice that my previous sentences are written in past tense. In recent communication with the museum, I learned that the jewellery gallery, under the new director, was in 2016 reshaped into a 'collection gallery' and now includes ceramic objects alongside the jewellery. The film and the electronic table have been removed. This is the prelude to the new integrated 'holistic' display of all art, ceramics and jewellery, which will open in February 2017.[20]

The future of jewellery collections in Dutch museums

Let us return to the Netherlands. Until recently, my country was known for its stimulating cultural climate. Today's no-nonsense art policy, however, forces museums to become event-machines yearning for media attention and high visitor numbers. At the same time, we can see a shift in the appreciation of objects. Ceramic and glass objects, jewellery and small aesthetic objects in general are dismissed as old-fashioned ways of design. The future is social, participatory and sustain-

18 Liesbeth den Besten: The Missing Link, Jewelry Presentations in the Museum, in Ben Lignel (ed.), Shows and Tales, *Art Jewelry Forum* 2015, 96–105.

19 Liesbeth den Besten: The Missing Link, 101–102. James Beighton was the MIMA curator from January 2007 to February 2014. The visitors sessions programme has stopped due to changes in staff and capacity, and the museum is considering 3D scanning technology to encourage visitors' use of the jewellery collection.

20 All information about the current situation is provided by Helen Welford, assistant-curator at MIMA, by e-mail 15 and 22 November 2016.

able, as the current exhibition *Dream Out Loud* shows (this is the first (juried) exhibition made by the new curator for applied arts and design at the Stedelijk Museum).[21]

Trends in design and thinking affect museums, their permanent collections and jewellery's position in them. In September 2016, only four years after the Stedelijk Museum's grand re-opening, it announced it would close the design department and build a new installation in the basement where all collections (visual arts, design, and applied arts) will be integrated. In recent months there has been some experimentation with this setup, for instance combining a sideboard by Gerrit Rietveld (1919) with three Malevitch paintings from 1917 and 1920. Nevertheless, the integration of jewellery poses quite a different challenge, for jewellery pieces risk being marginalised as miniature works of art, or they may become subservient to a broader storyline. The new permanent collection display will open later this year.

The examples of lurching Dutch (and foreign) museum policies that I have presented here show how fast things can change, especially with respect to jewellery: it lacks a fixed base – a dedicated museum. This is why a new initiative has come into being from within the Dutch community of jewellery collectors: a foundation for jewellery collections called the Stichting Sieraden Collecties (SSC).[22] Thanks to the unique situation of having a range of jewellery galleries in an unbroken succession from 1969 till today, the country has a relatively large community of jewellery collectors. The earliest of these witnessed at close hand the emergence of a new movement in jewellery. They participated in it by wearing the pieces, attending openings and visiting studios. Based on the idea that contemporary jewellery is part of cultural heritage and that the stories of the collector and the wearer

21 *Dream out Loud – Designing for Tomorrow's Demands,* Stedelijk Museum Amsterdam 2016. While there is no catalogue, there is a website https://dreamoutloud.stedelijk.nl/en/

22 Stichting Sieraden Collecties was founded by Ruudt Peters (chairman), Liesbeth den Besten (secretary) and Guus Bakker (treasurer). Thanks to good infrastructure and long-standing contacts with a range of jewellery galleries from 1969 till today, we know of a relatively large community of jewellery collectors. The earliest of these witnessed at close range the emergence of a new movement in jewellery; they participated in it by wearing the pieces, attending openings and visiting studios.

are of crucial importance, the immediate aim of the foundation is to create a safe haven for private jewellery collections. The foundation's ultimate goal is to establish a House of Jewellery with the mandate to collect and present jewellery collections in an inviting, multi-medial and open-depot setting that inspires visitors to discover the manifold aspects of jewellery. Engagement, experience, handling and interaction will be some of the key tasks of this new institution. The history of jewellery is not just a history of material objects, but also of social use and expression – this applies to historical as well as contemporary jewellery. Only an earmarked museum for jewellery can ensure the study and presentation of jewellery's position in society and art.

The history of jewellery is at least 100,000 years old. It identifies us as human beings and deserves a permanent and safe place in our cultural world – a place where its integrity is preserved and its identities as an aesthetic object and a social sign are recognized, studied and elucidated.[23]

23 Disclaimer: As a historian, one knows how fast things can change. The reader must be aware that all information in this article, although checked until the last possible moment, can be outdated the moment this book is published.

Pehr Hilleström d.e. *The Gallery of Antiquities, the Royal Palace, Stockholm*, 1776.
One of the first royal collections that opened in the aftermath of the Enlightenment
and the French Revolution. Photo: The National Museum, Stockholm

Collecting Strategies: Collecting for the Nation – Public Acquisitions and Private Donations

Knut Ljøgodt

Collecting has of course been an important phenomenon in the arts for at least the past two hundred years. But I sense that there is a new awareness about the topic in Norway today, demonstrated by several exhibitions as well as by this publication, *On Collecting: From a Public, Private, and Personal Perspective.*[1] In the following, I will discuss rather freely my ideas on collecting. I will concentrate on public collections – museums – but also on private collectors where they are relevant. To be more specific, I will discuss the interplay between the two.

My background is as an art historian. I have spent most of my professional life in museums, as a curator and as a director. I was previously a curator in the National Gallery in Oslo, and for the past eight years I was the director of the Northern Norway Art Museum in Tromsø. This has given me experience with building public art collections – one of the greatest privileges a museum director or curator has. It has also given me another privilege: to befriend and eventually collaborate with several private collectors, both here in Norway and internationally.

This is not a strictly academic article, nor does it present a fully developed collecting strategy. Rather, I would like to share some thoughts and ideas on principles and strategies for collecting, based partly on my own experience, partly on examples from different collections, both historical and contemporary.

Collecting for an institution, collecting on behalf of the public – for the nation if you like – differs from buying for a private collection.

1 This essay is based on a lecture given at the seminar *On Collecting: From a Public, Private, and Personal Perspective*, organised by Norwegian Crafts and KORO/Public Art Norway, Oslo, 13 October 2016.

Some principles are of course more or less the same, and I will discuss them in due course. But when collecting on behalf of a public institution – for the public – we should ask ourselves three basic questions: *why? what?* and *how?*

Why do we collect? This is the first basic question. *What* should we collect? This is perhaps the most interesting question from an artistic and scholarly point of view. The works that enter a collection should relate to the institution's mission or remit, understood as its specified area of responsibility. And finally, the pragmatic question: *how?* How do we manage to acquire the works we want, which often are selected according to our mission?

Why collect?

Let us start with the *why* question. According to the art historian Kenneth Clark, collecting has two origins:

The collector's instinct, if animals and children are any guide, has two roots; the desire to pick up anything bright and shining and the desire to complete a series; and these primitive instincts, under the stress of competition, memory, wealth, and other evolutionary factors, produced the first stages in collecting, the treasury and the cabinet of coins.[2]

However, I will not touch further upon the psychological or anthropological discussions of the origins of collecting; for this I refer to Margaret Wasz' essay, 'Why Do We Collect?'[3]

Rather, I will address the principles of why we should collect in a public context. I will start by referring to a popular work, the movie *The Monuments Men* from 2014.[4] It is not necessarily the best of films, but it tells an important story. It is about a group of art historians, architects, and artists who enlist as soldiers and are given the mission of rescuing the art treasures of Europe from Nazi destruction or theft during World War II. There is a horrible scene in this movie where we see the Nazis burning a storage facility filled with Old Masters. One of

2 Kenneth Clark: 'Introduction', in Douglas Cooper (ed.): *Great Private Collections* (London: Macmillian, 1965), 13.

3 Margaret Wasz's lecture 'Why Do We Collect?' was presented at the seminar *On Collecting*, and is published as an essay in this book.

4 *The Monuments Men*. Film, directed by George Clooney, Los Angeles, Columbia Pictures and 20th Century Fox, 2014.

the principal characters says: 'If you destroy the entire generation of a people's culture, it is as if it never existed!'[5]

This is at the core of why we have museums – public collections. In such institutions, we preserve and protect the cultural or artistic heritage of the past, for future generations. Furthermore, by making acquisitions, whether purchases or donations, museum collections define which part of today's art is to become tomorrow's heritage. Tomorrow's art history is what we acquire today. And of course, in a larger perspective, these collections become the basis for research and scholarship, eventually also for exhibitions, publications and education. The collection always is, or should be, at the core of a museum's work.

A brief history of museums and collections

Let us digress briefly to review the history of museums. Museums – that is, collections as museums – are a product of the Enlightenment. Many were founded in the late Eighteenth Century, in the period after the French Revolution. Royal and aristocratic collections, often housed in palaces, became accessible to the public. They were opened as museums, run by the state. This type of public museum can be found in continental Europe, in France, Italy, Spain and so forth. In other parts of Europe, particularly here in Scandinavia, the situation is not exactly the same. Here we have institutions that were actually founded as public museums. They were established by the government, for the benefit of the people. This was the case for the National Gallery in London in 1824, and for the National Gallery in Oslo in 1837, the first museum solely devoted to art here in Norway.[6] Bergen Museum was founded as a historical museum a few years earlier, but it also had an art collection that was eventually transferred to Bergen Art Museum (Bergen Billedgalleri – today a part of KODE). In addition, many art societies in Norwegian cities established and ran their own collections – referred to as permanent galleries – which became the forerunners of regional art museums. But let us not go into the entire history of Norwegian or European art museums. Suffice it to say that the collections of the

5 The quote is put forth by the character Frank Stokes, the group's leader, played by George Clooney.
6 Sigurd Willoch: *Nasjonalgalleriet gjennem hundre år* (Oslo: Gyldendal Norsk Forlag, 1937); Marit Lange (ed.): *Nasjonalgalleriets første 25 år: 1837–1862* (Oslo: National Gallery, 1998).

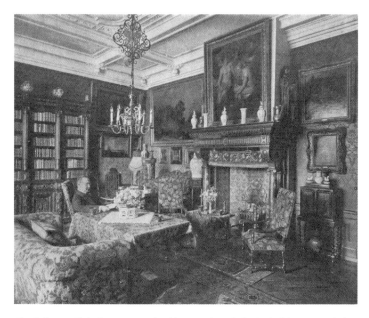

The Collector Christian Langaard at his House in Kristiania (Oslo), Surrounded by Old Masters. Reproduced after *Chr. Langaards samlinger av malerkunst og kunsthaandverk fra fortiden*, vol. 1, Kristiania (Oslo) 1913

National Gallery in Oslo and in other public museums were gradually built up during the Nineteenth and Twentieth Centuries, through public funding, but also thanks to important donations from private collectors and patrons.[7]

One of the earliest collections to enter the National Gallery belonged to the Norwegian painter Johan Christian Dahl, who also was something of a collector.[8] In Dresden, where he lived, Dahl amassed a substantial collection of paintings by Old Masters and contemporary artists. The National Gallery bought large parts of this collection in two bulks in the 1840s. Today, we can of course regret that the museum almost exclusively concentrated on the Old Masters – some of which still are considered important, some not – while they missed the opportunity to add important contemporary works by Caspar David Friedrich and other Romantics. But that is a lost cause.

During the late Nineteenth and early Twentieth Century, there emerged some very important collectors in Norway.[9] This should be recognised as the golden age of Norwegian collectors. The collections of Christian Langaard and Olaf Schou eventually entered the National Gallery, while in Bergen, Rasmus Meyer's collection became part of the core of Bergen Art Museum (today KODE). Well into the Twentieth Century, Rolf Stenersen stands out as a patron of modernist art. His collection became the basis of not one, but two museums bearing his name, in Oslo and in Bergen (today, they form a part of the Munch Museum and KODE, respectively). Late scions of this tradition are Sonja Henie and Niels Onstad, who in the 1960s founded the Henie Onstad Art Centre at Høvikodden outside of Oslo, with their substantial collection of French and Norwegian modernist works. But now we are getting ahead of ourselves, for we have already started talking about *what* we collect.

7 Knut Ljøgodt: 'About Collectors and Collections: A Historical Perspective', in Knut Ljøgodt and Andrea Kragerud (eds.): *From Dahl to Munch: Nordic Painting from the Canica Art Collection,* (Tromsø and Stamsund: Northern Norway Art Museum and Orkana publishing house, 2015).

8 Lange 1998.

9 Tone Skedsmo: *To norske kunstsamlere ved århundreskiftet: Olaf Schou og Rasmus Meyer,* dissertation in art history, University of Oslo 1976; Nils Messel: *Franske forbindelser* (Oslo: Messel Forlag, 2016).

What do we collect?

What do we acquire for public collections? This is perhaps the most interesting question for many people, but it is a matter of the given museum's profile. This is, or should be, defined by that institution's mission or remit. The mission is often defined by the government or other owners. Broadly speaking, a mission comes from society in general. But does the given museum have a specific profile – narrowed down – or is it general, as is the case for encyclopaedic museums?

The old National Gallery in Oslo was originally meant to be an Old Masters' collection, while Christiania Art Society was expected to take care of the contemporary artists. This was because historical art was considered essential for the aesthetic education of emerging Norwegian artists, as well as for the public in general. But soon the National Gallery started collecting what was then Norwegian contemporary art: works by Romantics such as J.C. Dahl and Thomas Fearnley, and eventually National Romantics such as Adolph Tidemand and Hans Gude.

The Museum of Applied Arts (Kunstindustrimuseet) was founded in 1876, as a result of the Arts and Crafts Movement. Similar museums were also established in Bergen and Trondheim, specialising in collecting crafts and eventually also design. We then jump a bit in history, to 1989. Then, the National Gallery's modern and contemporary collections were separated from the older collection, and the Museum of Contemporary Art in Oslo was established. The National Gallery then became strictly a museum for Norwegian and Western art history.

All the museums mentioned had specialised remits. In 2003, however, the government implemented a merger of the National Gallery, the Museum of Contemporary Art, the Museum of Applied Arts, and the Museum of Architecture. This resulted in the creation of the new National Museum of Art, Architecture and Design (mostly referred to as the National Museum).[10] This consolidated museum became an overall museum covering large areas of art history, contemporary art, architecture and design. So, from having individual museums with specific missions and profiles, we now have one large, general or encyclopaedic museum.

10 The National Touring Exhibitions were eventually also included in the National Museum.

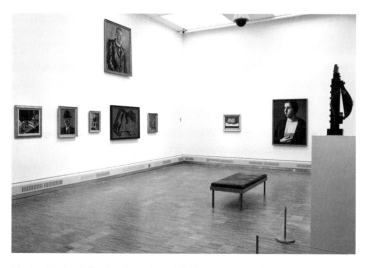

The Canica Art Collection. From the exhibition *From Munch to Slettemark,*
Munch Museum, Oslo 2013. Photo: Munch Museum /Canica, Oslo

The institution I have been associated with in recent years, the Northern Norway Art Museum, has a mission that is both general and specific. It is general in the sense that it should be the principle art museum and collection for the entire northern region of Norway. It therefore collects and presents art from Norway in general as well as international art. But its mission is also specific in the sense that it should showcase art from the region. This can include works by historical artists connected to the region – sometimes ignored artists brought back into the limelight – but also works by younger contemporary artists.

Let me here specify that when I use the term 'art', I mean it in the sense of what is traditionally known as fine art as well as applied art. I do not distinguish between the two because the principles are the same, whether we talk about collecting, research or exhibitions.

For sake of comparison, let us turn to London, where there are three major museums with a national mandate: Tate Britain, Tate Modern, and the National Gallery. Tate Britain specialises in British art, historical, modern and contemporary, Tate Modern deals with modern and contemporary art, mostly on an international level, while the National Gallery is in charge of Old Masters. In other words, each of these museums – though all are national – has its own very specific mission.

Collectors' strategies

The specific remit or mandate from society is one of the most important factors distinguishing a public institution from a private collector. The private collector is free to buy whatever he or she wants. Very often, collecting starts as a private passion, collecting *con amore*, but then develops into something more. The best private collections are often those that eventually have adapted a certain profile and strategy.[11]

Of the most interesting collectors here in Norway today, we must mention Erling Neby's sophisticated collection of Nordic Constructivist and Concrete post-war art, as well as the Canica Art Collection acquired by Stein Erik Hagen, in collaboration with the art historian Steinar Gjessing. The latter focuses on Early Modernism from Northern Europe, but also contains Nineteenth-Century painting. The Canica Collection is strategically built as a supplement to the holdings of public collec-

11 Ljøgodt 2015.

tions, particularly that of the National Museum, and frequently lends out to museums. The Norwegian-American collector Asbjørn Lunde in New York has a diversified collection but has focused on Norwegian and Swiss Romantic landscape painting. Lunde has frequently donated and lent works to museums in the USA, Great Britain and Norway. Viggo Hagstrøm started to collect *con amore,* but eventually concentrated on Norwegian mid-war painting and design. A large bulk of his collection was bequeathed to the Northern Norway Art Museum. In this context, we should also mention Hans Rasmus Astrup, Christian Ringnes and Christen Sveeas, who all have founded their own museums or sculpture parks, focusing on contemporary art. Among the younger collectors who have emerged during the last years, we find Nicolai Tangen with his collection of Norwegian and Scandinavian Twentieth-Century art, which eventually will form the basis of a new museum planned in Kristiansand.

Even historically, private collectors have specialised. Christian Langaard's collection became the nucleus of the National Gallery's Old Master collection, when it entered the museum as a bequest in 1922–23. It should be stressed that Langaard's collection was built in close collaboration with the National Gallery's high-profiled director, Jens Thiis. The collection was originally private but intended for the nation in a long-term perspective. This collaboration between the collector and the director was crucial: the director advised the collector on what to buy. The director possessed the art historical know-how, but he also recognised which works should eventually be included in the museum's collection. Jens Thiis was thus a great strategist; a collector on behalf of the nation. This is itself an interesting topic: museum directors and curator as collectors – people who do not collect for themselves but on behalf of institutions – on behalf of the public. But I am afraid we must leave that discussion for a later occasion.

Strategic collectors build a collection according to a certain profile. By founding a museum or giving their holdings – either as donations or long-term loans – to an existing museum, they also secure the collection and its works for posterity.

Collecting and scholarship
I would like to return to the aspect of scholarship and research in relation to collections. When I studied at the Courtauld Institute in London in the 1990s, I was struck by all the major works in the gallery's collec-

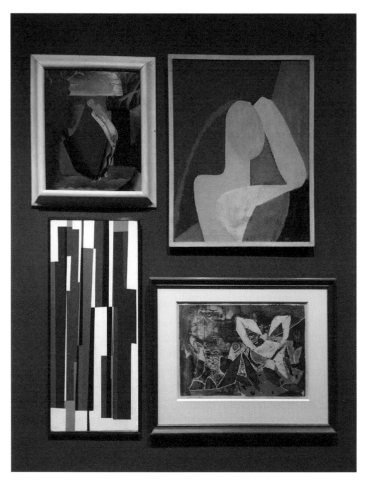

The Viggo Hagstrøm Donation, Northern Norway Art Museum, Tromsø. More than 300 works from Viggo Hagstrøm's collection entered Northern Norway Art Museum as a bequest 2015–16. Photo: Northern Norway Art Museum, Tromsø

tion. Many of these were well-known from art history books, such as Édouard Manet's *A Bar at the Folies-Bergère*. How could the Courtauld Gallery possess so many great art historical works? The answer is obvious: the collection was originally intended by the founder, Samuel Courtauld, as an example collection for the education of art history students. The many art historians who through generations have been associated with the Courtauld – whether as researchers or students – have, in their publications, used works from the collection as the basis for their research and as illustrations in their books.

We in Norway could learn from this: we should aim to be better at promoting our own art – and our museums' collections. One way of achieving this is to make our collections attractive to scholarship, and make sure that some of the works find their way into art history books – not only in Norway, but also internationally. Making collecting relevant to research is important: if there is no collection, how can students and researchers find material to write about? They can investigate the holdings of private collections, but it is very often the contents of public collections that will form the principle basis for research and eventually publications.

This relationship between collections and scholarship can lead to the rediscovery of forgotten aspects of art history, for example, marginalised artists such as Peder Balke, who has had great success lately. Many other Romantic artists, too, were despised during the Modernist period, yet many of their works were in the holdings of the museums – waiting be rediscovered and put into a new context in due time. However, there is a danger: if museums could deaccession – sell out – then these works would not have been preserved for posterity. Even if taste changes on account of tendencies in art history, museum directors and curators (or boards or politicians) should not be allowed to sell out from the collections. Deaccessioning is practised more frequently in other countries such as the USA, but in Scandinavia and most other European countries, this is usually prohibited by the institutions' own statutes, and also limited by the code of museum ethics.[12]

Nevertheless, the vagaries of taste sometimes result in artists being excluded from collections. Their achievement might not have been recognised during their lifetime. This means museum directors

12 http://icom.museum/professional-standards/code-of-ethics

and curators should also always have an open eye to filling the gaps. A critical aspect of scholarly work can lead to the rediscovery of individual artists and certain themes. Here, museums and collections should play an important part in the on-going rewriting and redefinition of art history.

Some private collectors as well as art dealers have also been important in this process of re-evaluating art history. I have already touched upon Peder Balke. In the 1960s, when many of Balke's masterpieces still not had entered museum collections, the aforementioned Asbjørn Lunde in New York started collecting this artist's works. Now considered a legendary collector, Lunde has played a key role in bringing Balke and Norwegian art to the world. This is one example of why the interplay between curators of public institutions and private collectors is crucial.

Programming strategy

Museums should have an overall programming strategy that includes exhibitions, research, education – and of course a collecting policy. The collecting policy and the rest of the programme should reflect each other. It should be natural for an artist or theme that is particularly relevant to a museum's profile to be shown in exhibitions as well included in the collection. Sometimes, while preparing an exhibition, a museum will actually commission a work from an artist (if a living artist), or they will acquire works by the featured artist, whether it is a contemporary or historical artist. Other times, the museum will purchase a work or hopefully receive a donation in connection with or after an exhibition.

To conclude the discussion on what we collect: most Norwegian museums today have a rather general profile. But could a more clearly-defined strategy and profile for the individual institutions make the programme more interesting to both the general public and the art community, and thereby more visible on a national and international level? This is a question I ask, and I leave it for your reflection.

How do we collect?

Now, the more pragmatic, and to many, the most interesting part of the strategy: how to get the works you want for a collection. Generally speaking, there are three ways: you can acquire or purchase with whatever money you have; you can accept donations or long-term

loans from private patrons and foundations; and the nation can set up a public foundation for purchasing art. This latter idea has existed in the art world for many years and has recently been re-introduced as a topic for debate.[13]

Public funding, private donations and long-term loans

Let me start with the institution itself buying works of art. This requires funding, public funding, which is the traditional model here in Scandinavia and in most of Europe. At least until recently, public institutions have basically been publicly funded. I would like to keep this model, but I believe it is also important to collaborate with private patrons and sponsors. Yet if society wants to keep and maintain public institutions, it is crucial to fund them properly. I do not refer only to funding the running cost but also to providing a proper acquisition budget. Further, I would like to see a budget reserved for acquisitions, so that it is not used for other purposes. But this is a political decision.

Compare this with the situation in the USA: the holdings of the museums there are almost exclusively donations or long-term loans from private patrons. The exceptions are the Smithsonian – an institution based in Washington D.C. that includes many museums – and the National Gallery of Art, which is also in the nation's capital. These are the only national or federal art institutions in the USA. Most of the others are foundations, sometimes half-public/half-private, sometimes public or municipal, but more often they are private, and the acquisitions are more often than not donations or long-term loans. If you go to the Metropolitan Museum of Art in New York, you will see a beautiful room featuring Scandinavian and German Romanticists. If you look at the labels, you see that quite many of the works do not actually belong to the Metropolitan Museum. Some are donations, but many are long-term loans from private collectors.

Long-term loans, then, are valuable supplements to purchases and gifts. The works can be placed in the museum and used for a longer period as part of the institution's own collection for research, exhibitions and education. In addition to deposits from private collectors, I believe that public museums to a much greater degree should

13 http://www.klassekampen.no/article/20160914/ARTICLE/160919934; http://kunstforum.as/2016/09/et-nasjonalt-innkjopsfond-for-kunst

exchange long-term loans, for the benefit of the public. In recent years, we have also seen how foundations here in Norway, in particular the Savings Bank Foundation DNB, support public institutions by making long-term loans.

Let us return to the question of donations. Historically, substantial parts of public collections are gifts from private patrons, for instance Langaard and Stenersen. Even today, many collectors support the arts by founding their own museums or donating or lending to existing institutions, as mentioned above. Donations are often the result of a long-term collaboration with a collector or an artist. In fact, artists can often act as patrons: Jan Groth has collected for many years and gifted most of his holdings to different museums, though the major part goes to Stavanger Art Museum. Recently, Olav Christopher Jenssen donated almost one hundred of his own works to Northern Norway Art Museum. In both cases, the artists had a long-standing relationship to the institutions in question. In certain cases, one can also approach a sponsor directly and ask for help with funding an important acquisition. These different strategies can secure important works which would have been impossible for the institution to acquire on its own.

Lost opportunities

Before returning to the question of why we should have a separate foundation for buying art, we must ask: why not just give the money to the individual institutions? Obviously, the institutions should have their own budgets. But Norway has a sad story to tell that goes back to the Nineteenth Century, of individual works and entire collections being lost. If you read the history of public art commissions at the time, you find that many plans were developed but never executed. There were several plans for the University of Christiania (Oslo) and the Royal Palace, but few were ever executed. This was partly due to a lack of funding but also to intrigues and quarrels in the local art community.

There were some substantial collections here in Norway in the early 1900s, particularly of French Impressionism and early Modernism.[14] Most of the works were sold to international buyers and left the country in the mid-war period, as a result of the financial crisis. One striking example is Paul Gauguin's magnum opus *Where Do We Come*

14 Messel 2016.

From? What Are We? Where Are We Going?, which used to belong to the collection of Jørgen Breder Stang (also known as I.B. Stang) in Oslo. This painting is now one of the major attractions of the Boston Museum of Fine Art. Stang also owned Paul Cézanne's *The Card Players*, which was picked up by Samuel Courtauld and today hangs in the Courtauld Gallery. Another important collector from that period was Tryggve Sagen. Together with Christian Tetzen-Lund from Denmark, he bought a collection of Matisse paintings from the Stein family, but this too was eventually sold. Some works from these collections were secured, either as gifts or purchases by the Friends of the National Gallery, but most were lost. In hindsight, we can regret the loss of these works. As the art historian Ellen Lerberg points out: 'If the Norwegian authorities had been prescient, the National Gallery's collection of French art could have been many times larger and contained a great many choice pieces ...'.[15]

With these works, Norwegian museums could have been world attractions. How can we prevent this from happening again? How can we secure major works for our collections?

A national art foundation?

This brings me back to the idea of a public foundation for buying works of art. Norway is a rich country today, and I think we could allow ourselves to buy more art for the public, and to support the artists.

If you look to Denmark, you will come across the wonderful New Carlsberg Foundation. This supports the arts, both through public commissions and by acquisitions for museums. This, and other foundations, is the reason why Danish museums can still acquire works by Degas, Monet, Gauguin – world-famous art. Recently, the National Gallery of Denmark managed to acquire an important painting by Friedrich, thanks to support from different Danish foundations.

I believe that with Norwegian money, for instance with surplus from the oil fund or other parts of the nation's income, we would be able to set up a similar foundation – if there is a political will. Individual museums would be able to apply for acquisition money, and thus get the funding to secure major works that would otherwise be lost.

15 Ellen Lerberg: 'Nasjonalgalleriets samling av fransk kunst – kun gjenspeiling av en direktørs preferanser?', *Kunst og Kultur* 2001, p. 23.

It should be stressed that decisions regarding which works to acquire should remain in the hands of the museums themselves, that is, the directors, curators or acquisitions committees. The foundation's role should be to support acquisitions when needed.

Conclusion

In this essay I have attempted to outline some strategies for collecting. I believe a combination of these will be the best path for Norwegian museums to follow in the future: collaboration between public institutions and private collectors – a so-called public-private-partnership – is a model that takes the best from both the Scandinavian-European and the US system. If we could supplement this with a national art foundation to secure major works, we would have a strong Norwegian art scene in future years. These strategies could also strengthen scholarship and education, and could make it possible to organise exhibitions on an international level. But it also requires that we put some of our wealth into art. Then, Norway could become a superpower in the global art world. Norway today is a rich nation – of money. If public money is used intelligently, and if we become even better at collaborating with private collectors and patrons, we could build world class art collections – and thereby make our mark on the international art scene. The challenge is there, for the Parliament, the Government, the Minister of Culture as well as for other politicians – but also for those of us in the art world.

Olav Christopher Jenssen: *Rigoletto/Generation 3*, 2007–08. A series of glazed ceramic sculptures. Included in the Olav Christopher Jenssen Donation to Northern Norway Art Museum 2014. Photo: Northern Norway Art Museum, Tromsø © Olav Christopher Jenssen

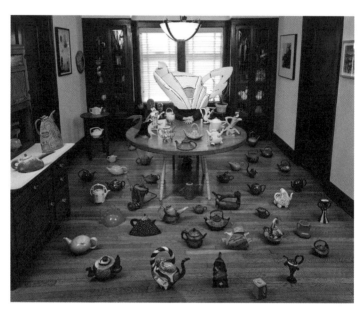

Yuka Oyama: *Collectors – Teapot*. 2013. C-Print. Photo: Becky Yee

Collectors

Yuka Oyama

My artistic practice lies at the intersection between contemporary jewellery art, wearable sculpture and performance. I examine the artistic language that is constructed with two intertwined components: a thing and a person. I am especially interested in the intermediary relations between objects and a person.

An Australian man buys a large ship so that it can float in his small pond next to his house. A woman marries a piece of the Berlin Wall. I became fascinated by these kinds of anecdotes about objects that grow beyond their function. They become alive in our minds, start demanding changed conditions, cause inconvenience and make us behave differently than we would otherwise. But we still need them. Using this situation as a point of departure, I investigate the fantasies that people project onto domestic objects, also certain inherent agentive qualities of objects that result in an intimate sentimentalising of them, despite their inanimate nature.

In this essay, I write about my art project *Collectors*, which touches on interrelations between collectors, collected objects and the spaces these objects occupy. The project resulted in a series of photographic portraits, also called *Collectors*, which I created during my artist-in-residence period at the SPACES Gallery in Cleveland, Ohio in 2013. I sought to articulate how we are compelled to own and collect objects and how they can complicate our everyday life.

Acts of collecting and acts of hoarding are similar in that they both involve possessing more than one object. What clearly distinguishes collecting from hoarding is discipline. Hoarding is an endless accumulation without selection, and it shows a lacking awareness of content or quantity and quality. Collecting, by contrast, demands the updating of knowledge, archiving, consideration of structures/systems, and maintenance of the items' condition. In some situations a collection can have several sub-series, each of which can come to an end. From there, the collector can resume acquiring other models to create further series.

The value of a collection is therefore determined not only by the purchase and sale price of the objects, but also by all the activities related to the collection: the time spent searching, accumulating, and maintaining it, not to mention the patience and generosity required to share one's living space with the objects. A collection may even restrict its owner's mobility, and oftentimes such a predicament appears awkward and senseless to others.

The search for collectors

My original intention was to interview collectors and to create masks. I was interested in finding a way to express their uncontrollable gravitation towards particular objects. I searched for local collectors via the Internet, posting announcements on *craigslist* and observing local auctions on *eBay*. I also posted flyers in thrift shops.

I then met seven people who collect the following objects: teapots, typewriters, sewing machines, moon shelves, Space Age furniture, works of art from northeast Ohio from the period 1910–1920, and carrot products. I judged a collection as legitimate for my project if it had been accrued over many decades, and if the collector expressed an overwhelming emotional involvement with the collection.

Interviews

I visited the homes of collectors who showed a general interest in taking part in my project, despite not being sure if their collections were inspiring or whether I would feel comfortable working with them. I arranged further meetings with most of the collectors. Some of them I met over the course of many days. I asked each collector the same set of questions:

- How did the interest in these objects begin?
- When did this collection start and how long has it been going on?
- What is so appealing about these objects?
- Which features/aspects/qualities are important?
- What are the rules of this collection?
- Which piece in your collection represents you most?
- Background knowledge of these objects

The doppelgänger

What fascinated me most of all was to see the real life connected to the collected objects. They took over the living space of the collectors. I was often curious as to whether the house or apartment was there to house the collector or the objects. Each item had its individual attraction. Accumulated over many years, the collection had become a group of pleasurable objects. The mass of the collection as a whole gave it a new kind of meaning. It also created an environment within which the person could experience joy, pride, comfort and rejuvenation; it could be a means of escaping from the conventions of the everyday.

I then recognised something even more significant about the relationship between a set of objects and a collector: the collector has a need to possess more than one object. This is probably because a number of objects, when they are assembled together in one room, start to reveal something previously unknown about themselves. They are the doubles and multiplied extensions of the person who acquires them, from which that person can learn to understand more about herself or himself. In other words, the collection appears to help construct and reassure the collector's sense of self.

If the search for the *self* is related to the act of collecting, then what the assemblage of objects shows is the inner, multifarious faces of the person. I became convinced that I wanted to make individual portraits of the collectors in the surroundings where their collections were housed; by doing so, I would turn them into one of their special objects. In other words, by placing them amongst their collected objects, I sought to display any likenesses and affinities between the collectors and their objects.

Another aspect I wanted to emphasise was the community that a person builds through a colony of special objects, in a place devoid of other human beings.

Teapots

The collector of teapots (T) has been involved in the collecting activity for twenty years. Most of her teapots were found locally, except for a few bought on holidays abroad. She is interested in the playful ways in which ceramic artists exaggerate elements of teapots such as the body, handle, spout and lid. She asks: 'What is beyond something that is simply good?'

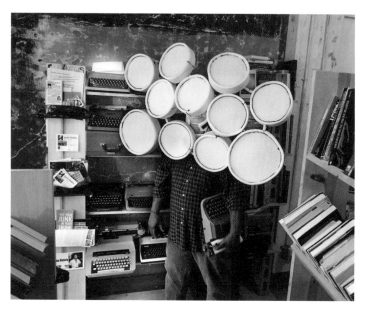

Yuka Oyama: *Collectors – Typewriter*. 2013. C-Print. Photo: Becky Yee

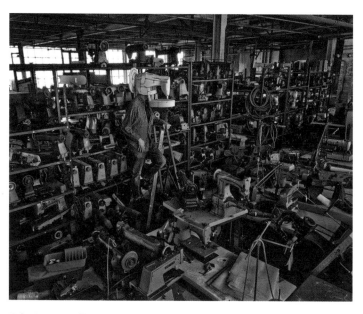

Yuka Oyama: *Collectors – Sewing Machine*. 2013. C-Print. Photo: Becky Yee

After interviewing her, I created a mask for her out of polyethylene material. I then visited her with Becky Yee, a photography artist with whom I have worked since 2003. We constructed a stage in her living room where most of her teapots are stored, and we photographed her wearing the mask in the midst of selected objects from her collection.

Typewriters

The collector of typewriters (TW) is a writer who produces all his manuscripts on typewriters. He carries one around in the same way that others carry laptops, going to cafés with them, even though people complain that his typing is loud.

His two most important criteria for evaluating typewriters are the shape of the keys – perfectly round – and whether they feature large letters in fonts such as *Palatino* or *Bookman Antiqua*.

Typing on typewriters is also part of TW's creative practice. His daily goal is to write ten pages, and his rule is always to write first and reflect later. This enables him to write from the heart rather than the mind.

Sewing machines

The collector of sewing machines (S) is an engineer who repairs analogue and highly digitalised electric sewing machines. He was trained in the USA and Europe and has repaired hundreds of sewing machines.

In the 1970s and '80s, there were twelve sweater factories, two suit factories and two automobile-seat manufacturers in Cleveland, Ohio. These companies employed over 10,000 people who could sew. Then the USA opened up for free trade with Mexico and China, which resulted in the collapse of the textile industry in the midwestern United States. S could not bear to see sewing machines from liquidated factories being abandoned and left to stand outdoors. He picked them up and took them home. This resulted in a loft full of sewing machines. Some of his sewing machines are so rare that they are regularly loaned to the Smithsonian Museum.

He told me an inspiring story about the dual phenomena of old, experienced needle workers who can embroider perfect fonts by hand, as if done by a high-end digital sewing machine. Meanwhile, there are highly sophisticated automated sewing machines that can produce irregular stitches meant to imitate hand-sewing.

Moon shelves

Moon shelves have steps that can hold small figurines, for instance angels. They are also called 'Stairways to Heaven'. They were popular from the 1930s through the '50s and were made in woodwork classes, as exercises for learning how to cut zigzags and curves.

The collector of moon shelves (M) owns about 200 such objects, and approximately 100 of these hang in her living room. The mother of M's college roommate used to collect moon shelves; they were made of wood and showed a moon with steps leading up to it. Many years after college, M saw a moon shelf in a shop near where she lived. It had many mirrors and was made by the shop owner. M did not buy it, but she has regretted it. About 30 years ago, while she was on vacation in Pennsylvania, she bought her first moon shelf. That was the start of her collection.

To M, moon shelves are more meaningful as symbols than as objects. They are metaphors, for instance for spiritual journeys and longing, and for the desire that something be other than what it actually is. The steps are elevations; they move upwards and reach beyond the moon. The stairs remind M that there are different stages and chapters in life.

She has no idea why she collects them. There is simply no end, she replies. Moon shelves represent a quest! There is something appealing about a theme with *endless* variations. They are unique handmade objects, and each one has a different interpretation. There is always novelty in finding a new version.

Space Age furniture

The collector of Space Age furniture (SA) has always fancied surrounding herself with futuristic objects. She discovered Space-Age furnishings when her parents took her to a furniture store: there she fell in love with a curious chair that was ball-shaped and had a built-in stereo sound system. This and other objects with organic shapes, bright colours and alien-like appearance made her feel like she was living on another planet. Her collection represents an attempt to create another world, one that is more open and accepting.

Artworks from northeast Ohio from 1910–1920

The collector of artworks from northeast Ohio from 1910–1920 (A) describes his practice as collecting 'art from the teens'. This period, he

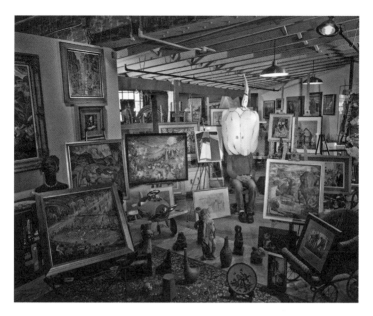

Yuka Oyama: *Collectors – Artwork*. 2013. C-Print. Photo: Becky Yee

Yuka Oyama: *Collectors – Carrot*. 2013. C-Print. Photo: Becky Yee

explains, was the heyday of Ohio and its art, when John D. Rockefeller, the founder of the Standard Oil Company, and other industrial giants were patrons of local artists.

A describes his collection as having value, but not necessarily as an investment. Activities like eating, drinking, travelling or going on holiday do not hold value for him. His art collection simply gives him pleasure. He can enjoy the pieces every day.

He mentions that looking for art on *eBay* is obsessive: the automatic alert rings all the time, and he knows the people he is bidding against. He likes the feeling that 'there will be no more of this', so he focuses on collecting works by deceased artists. His collecting will continue as long as he can pay the bills.

Carrot products

The collector of carrot products (C) is known as 'the carrot man' in his local community. An entire room in his apartment is dedicated to his collection.

It ranges from packaging, magazines, cooking recipes, toys, ceramic figures, textiles, clothing and electronic gadgets to hand-crafted gifts from his friends. His rule for collecting is that carrots should be the dominant aspect, not bunnies. The most precious pieces in his collection, he says, are the hand-made gifts from friends, because they are absolutely one-of-a-kind.

C wants to build a museum of carrot products: going public with his collection would gain him the freedom to collect something else. This is another interesting notion of collecting. Most of the collectors I interviewed mention that their *next step* is to build their own museum or to find someone who will offer them a space in which to create a museum.

Conclusion

I have realised that I have been collecting collectors. Through this work of investigating people's relationships to collections, I have been exposed to diverse life values, social surroundings and lifestyles.

In 2008 the British anthropologist Daniel Miller published *The Comfort of Things*, a series of selected written portraits of 100 Londoners who live on the same street. His intention was to study the domestic life hidden behind people's public façades, to better understand the human condition by using an *inside* perspective to view contemporary

life. Miller's method was to interview residents who volunteered to participate in his project. He visited their homes and listened to them talk about their relationships to objects.

I believe what I am doing shares similarities with Miller's research, but that it is a material-based art project that includes wearable sculptures and photography as well as a publication. I have discovered the potential to develop it into a project that portrays collectors worldwide.

Billedkunstneren 1/1975. Journal for Norwegian artists.

The Becoming of a Public Collection

Trude Schjelderup Iversen

According to the Norwegian art historian Gunnar Danbolt, the art institution is like a lobster trap: it is hard to get into, but impossible to get out of. This metaphor points to the complexity of Norwegian cultural policies, with their various support programmes and grant arrangements on the one hand, and the legal system on the other. It also indicates something about the institutions set up to enforce the contemporary political agenda. The policies, support programmes, grants and legal system form the basis for Norwegian arts funding, which could be describe as *art without market* (and by that I mean the private art market).

I begin this article by reviewing some of the most important historical events that form the background for how Public Art Norway (*Kunst i offentlige rom*, henceforth referred to as KORO) not only was established but also became one of the most important commissioners of contemporary art in the country. I then discuss KORO's roles as a collector, caretaker, knowledge producer and facilitator of people's encounters with art in public spaces. In the final sections, the Hessel Collection in upstate New York serves as an interesting case to compare with KORO. It casts KORO in sharp relief and points to a way forward for reactivating and increasing the cultural value of KORO's collection.

A brief history

Traditionally, Norwegian culture policies for artists have had many purposes: to educate, stimulate new artistic production through grants and project funding, honour high achievement, assist elderly artists, improve welfare and living conditions, increase the public use of artworks and provide reasonable compensation for their display.

KORO's support and funding structure rests on two principles: the legal and the political. The legal basis is made up of intellectual property and copyright law. The political basis is the political will to support the arts above and beyond those avenues provided by the legal basis and the art market. The history of this funding structure happens

to be the history of the struggles of artist organisations in Norway. But how did KORO come to be established?

In 1974, the Church and Education Department (Ministry of Culture) worked on a comprehensive art and culture report and asked artist unions for input. The opening of the annual Autumn Exhibition hinted at what was about to come, as artists collectively raised an important question:

> Artists do not get a cent in compensation when their works are displayed and used in society. Is this reasonable?

That same year, Artist Action (*Kunstneraksjonen*) was formed as an interdisciplinary coalition of creative artists. More than twenty organisations for artists, makers, writers, composers and filmmakers came together to agitate for improving artists' social and economic conditions; this was seen as the very foundation for free, autonomous art. The group first decided to create a new national organisation, after which it presented three demands, in the now well-known Three Point Program:

1. Compensation for any public display / use of a work of art
2. Increased (public) use of art
3. A guaranteed minimum income for all working artists when points 1 and 2 do not provide reasonable income

Over the next four years, Artist Action coordinated several campaigns, open meetings, demonstrations and boycotts. Eventually, the Ministry of Culture approved the Three Point Program. Compensation would ensure that artists received remuneration for the public use of their art, whether in libraries, television programs, schools or the National Gallery. The increased use of art would ensure an economic basis, thanks to fees, and the minimum income would apply in accordance with the minimum income paid to farmers and fishermen. The points in the Three Point Program were listed in their order of priority, thus stressing that this was not a matter of 'alms' or some sort of charity.

Another two years passed before KORO was founded in 1976. As a government agency under the Ministry of Culture, it has aimed to ensure commissions for artists but also to bring 'art to the people', based on the idea that everyone should have the right to experience art in their

daily environment. KORO was later to enforce a law requiring that 0.5 to 1.5 percent of the total cost of every new state building be invested in art. KORO quickly became the most comprehensive commissioner for artists in the country. Today, 50 to 60 new public buildings are being constructed every year: hospitals, prisons, cultural centres, university buildings, train stations, health centres, military barracks, and so forth. Of KORO's annual budget of 50 to 60 million NOK (about 8 million USD), half goes to commissions and direct purchases.

The founding of KORO was a direct result of artists' agitation in 1974, and together with the guaranteed income and compensation for the public display and use of art, KORO's annual production, *still to this day*, secures a certain social welfare for artists. But many have argued that the hands-on public policies have also severely diminished private interest in funding the cultural field. The reasons for this, I think, are complex. As a relatively young nation lacking in philanthropic traditions or a robust community of art collectors, Norway provides artists with very few choices other than state funding.

This is the political and historical backdrop for KORO – a true child of the artists unions' struggles. We must understand that KORO's 40-year history of commissioning public works of art is not primarily a matter of social welfare but of a will to increase the use of art in public spaces and to make sure art by contemporary artists is available throughout the country.

KORO as a collector, caretaker, knowledge producer and facilitator

The last thing on KORO's agenda when it was established was to build a progressive or comprehensive public art collection. But KORO did start accumulating artworks by contemporary artists, and in this respect, the driving force was *quantity* rather than quality.

KORO's strategic plan for the period 2014–2019 can be seen as a framework for a renewal process that will have implications for all parts of KORO. The main principles in the strategy are to find a balance between art production, maintenance, knowledge production and facilitating the public's encounter with art in public spaces. The plan entails that KORO change from being an institution which primarily produces and finances art projects, to becoming an institution that increasingly emphasises the equal importance of art production, maintenance, knowledge production and facilitation.

KORO has principal management responsibility for the art it provides for governmental purposes. This means it must maintain an overview of the works of art and ensure that they are properly cared for. Furthermore, the office must proactively give advice and guidance regarding the management of the artworks.

The turning point in KORO happened, in my opinion, over the last three or four years, when KORO – within the budget – increased its art maintenance department from one person to four. This marks an important shift within KORO, but it is only a first step, and much remains to be done. In 2014 KORO was evaluated by its owners, and according to the final rapport, there was a 'structural mismatch between, on the one hand, the financial resources for production and grant administration, and on the other hand, the maintenance, collection management, knowledge production and efforts towards enabling the public to engage with high-quality art in public spaces. It seems obvious that in the coming years, it is important to create a better balance in the economic conditions, so that all KORO's tasks can be consistently performed at a high level.

KORO as a reactivator of art

In the last three to four years, KORO has curated art projects that are based on the very idea of the public collection: curator Marianne Zamecznik's project at Bæreia Veteransenter is a good example: Here the artist Hedevig Anker wanted to give new relevance to works of art which she had found in a storage space at the veterans' centre. This was achieved primarily by reframing the works in modern museum-style frames and re-locating them to a more public part of the institution's new building. Anker also created a montage of 12 images entitled *Horisonter (Horizons)*. These images are details taken from artworks in Bæreia Veteransenter's collection.

By this artistic gesture, Anker *reactivated* the collection. Reactivation is linked to the current tendency that has been called 'correction-curating'. In this endeavour, neglected or overlooked artists are being brought out into the light at the same time as recent art history, national institutions and art critics are criticised for failing to acknowledge these artists. Often done very successfully, it is a curatorial method that aims to insert neglected artists into the canon. The artist Eline Mugaas has been an important figure within this practice. One thinks also of Marit Paasche's long-term commitment to promot-

ing Hannah Ryggen. A third example is Oslo Pilot's 'recomposing' of Siri Aurdal's *Bølgen* (*The Wave*), an iconic sculpture originally commissioned for a schoolyard in Oslo. Stina Høgquist's exhibition featuring the art of Sidsel Paasche is another example, and I could name many more. The reactivation of artworks that have been hidden away or neglected often starts with making a government institution *aware* that it actually has a collection of interesting or important works by key artists, or even a very special or rare piece by a certain artist. But needing to make an institution aware of the cultural value of the art on its premises causes one to suspect that the institution may not have been sufficiently involved in the committee that organised the art project to begin with.

The challenges of the multi-party committee model

The aforementioned evaluation in 2014 also highlighted challenges regarding the committees that have traditionally been used for organising new art projects for state institutions. These typically consist of the architect, the builder, one representative from the institution that will use the building, and KORO's art consultants. This representative and democratic model is based on the need for political legitimacy, and the selections of art are made through achieving consensus amongst committee members.

Let's pause here for a minute. A group of five needs to agree? Legitimacy, not artistic value, underlies the need for consensus, and it is more important than finding the best art project for the specific situation. The 2014 evaluation shows that this model has limitations in the sense that the institution that will live with the artworks and maintain them on a daily basis is not adequately involved through its representation in the committee. The standardised model of multi-party committees makes it challenging for KORO to have a long-term commitment towards building a collection, towards taking care of what is already there and to highlight or reactivate important works of art. For that, there are too many interests involved, and political legitimacy triumphs over artistic value.

KORO has therefore in recent years had several pilot projects showing that when you replace the multiparty committee with artistic and curatorial authority – let the experts be experts – interesting possibilities emerge, especially when seeking to reactivate a collection. The Sami Parliament (*Sametinget*) in Karasjok, for example, now has its

Siri Aurdal's *Bølgen (The Wave)*. Sculptur/installation.

own Kåre Kivijärvi wing. This is after years of the Kivijärvi works having unsuitable placement and being partly destroyed by sunlight. The photographs by the renowned artist are one of his most important series.

The history of photography as art, where it is not treated solely as a visual medium but as art in its own right, is relative short in Norway. Kivijärvi was a pioneer in this respect (he was the first photographer to present work at the *Autumn Exhibition* in 1971), but also one of the most important artists in Norway after 1950.

Some of the photographs in the Sami Parliament had been destroyed while others were hidden away in private offices. We were able to start a process of reprinting copies by closely following Kivijärvi's own method. The project involved rightful and un-rightful heirs, the National Library and printing houses in Paris and Oslo. I worked closely with the director of the Sami Parliament for one year, and the project also included a newly commissioned work by the young Sami artist Outi Pieski.

I am very glad I did not have to work within the multiparty committee-model, and I do not think that adding more interests to the table in such a situation would have been fruitful. An authoritative curatorial gesture can sometimes go a long way.

The example of the Hessel Collection

For sake of comparison, I am going to jump from one extreme to another, from the Norwegian cultural landscape to the USA and to another collection I have worked with professionally: The Mariluise Hessel Collection. Permanently located in the Center for Curatorial Studies and Hessel Museum of Art (henceforth the CCS Bard and Hessel Museum),[1] it includes more than 3,000 works by more than 400 of the most prominent artists of the Twentieth and Twenty-First Century. Exhibitions are presented year-round in the CCS Bard and Hessel Museum, providing students with the opportunity to work with world-renowned artists and curators. The exhibition programme and the Hessel Collection also serve as the basis for a wide range of public programmes and activities exploring art and its role in contemporary society.

1 The Center for Curatorial Studies and Hessel Museum of Art are located on the campus of Bard College in Annandale-on-Hudson, in upstate New York.

Kåre Kivijärvi: *Fra de store banker* (1959/1961). B&W Photograhy.

Kåre Kivijärvi: *Kvinne (portrett) i Nesseby* (1972). B&W Photograhy.

Hessel's collection includes notable works representing many of the foremost movements in contemporary art: Minimalism, Arte Povera, Transavantgarde, Neo-expressionism, Pattern and Decoration, Post-minimalists, and New Media, among others. Some of these works are by Janine Antoni, Georg Baselitz, Paul Chan, Felix Gonzalez-Torres, Rachel Harrison, Mona Hatoum, Donald Judd, Sol LeWitt, Bruce Nauman, Nam June Paik, Raymond Pettibon, Sigmar Polke and Rosemarie Trockel. Recent acquisitions include works by Chantal Ackerman, Andrea Frazer, Sherrie Levine, Philippe Parreno, Rikrit Tiravanija and Thomas Hirschhorn.

Marieluise Hessel bought her first painting, a 1966 nude by Gerhard Richter, for less than $1,000. Through the years she continued collecting the broad range of works that are now in the holdings of the CCS Bard and Hessel Museum. A leading philanthropist, Hessel made the founding gift of $8 million to establish the CCS in 1990; she recently gave another $8 million toward the museum.

What I find interesting here is not her collection as such or that she built a museum. After all, many collectors do that. What is impressive in this case is the willingness to found and support one of the world's leading curatorial education centres. The CCS Bard is an international research centre dedicated to the study of late Twentieth- and Twenty-First-Century art, curatorial practice and contemporary culture. It offers a unique graduate program in curatorial practice at the Master's degree level, the study of museum activities, exhibitions, art criticism and the interpretation of art. The collection in its entirety is available to students, scholars and visiting curators.

The 'double' character of art

The most important art theorist of the Twentieth Century, the German philosopher Theodor W Adorno, in his main work *Aesthetic Theory,* describes what characterises a work of art today.[2] Adorno tried – and succeed – in establishing an understanding of what can be called the double character of art: it is autonomous (*auto-nomos* – self regulated) and a social fact (he calls it a *fait social*). What does Adorno mean by this?

2 Theodore Adorno: *Aesthetic Theory*, Gretel Adorno & Rolf Tiedemann (eds.), Robert Hullot-Kentor (English trans.) (London: The Athlone Press, 1997), 225 ff.; originally published as Ãsthetische *Theorie* (Frankfurt am Main: Suhrkamp Verlan, 1970).

Of central importance for Adorno's characterisation of art's autonomy are those passages in his *Aesthetic Theory* where he describes the work of art as a 'split object' – as 'thing' and 'sign' or as 'material configuration' and 'spirit' – and in which he emphasises the specific processuality of artworks. Works of art are configurations of sensuous material and, at the same time, 'spirit'. What is important here is that for Adorno, the double character of the artwork as thing and sign, as material configuration and spirit, is the source of the artwork's specific processuality. It is the artwork's being, as Walter Benjamin would have it, an infinite medium of reflection.

The being of the work of art, Adorno says, is a *becoming*. The artwork itself changes in the history of its reception. *Interpretation* and *art criticism* comprise the site of this becoming.[3] In order for art to be art, so to speak, it needs interpretation, art criticism and theory. If not, it falls dead to the ground. Public art is especially at risk from this, as it is surrounded by a very weak discursive apparatus.

The becoming of KORO's public art collection is therefore dependent upon an awakening from the dead or a brining back to life of the artworks, artefacts, art production and projects that have taken place throughout Norway for 40 years. KORO's 7,000 works of art must, in the coming years, be understood as an art collection that should be well-managed and well-maintained according to the same principles that apply to other art collections.

The Hessel Collection is one of the most studied, reflected upon, activated, reactivated, curated and written about collections in the world; it is a constant object of criticism and recent art historical writing. KORO's collection, by contrast, is under-reflected, rarely a subject of theoretical investigation, and until recently barely taken into account and to some extent poorly cared for. The works most certainly have not been objects for art criticism or research. This situation implies a severe loss of culture value, and it is not simply due to the works not being sufficiently taken care of in a physical and practical sense. We cannot continue to support a system that produces works of art for public spaces but leaves them to a life of ignorance and invisibility.

3 Theodore Adorno: *Aesthetic Theory,* 194.

Hanne Friis: *Sirkel, et minne om LB*. Wall piece. Textile. 2016.
In the Collection of KODE – Art Museums of Bergen.

A Motivation and Model for Collecting: The Norwegian Craft Acquisition Fund

Nanna Melland

The Norwegian Craft Acquisition Fund (*Innkjøpsfondet for norsk kunst-håndverk*, INK) is a unique institution that secures high quality contemporary craft for museum collections. Since its founding in 1990, INK has contributed significantly to increasing the profile and public acceptance of the field of contemporary craft in Norway. The combined efforts of INK's members raise the quality of the contemporary craft collections at the three museums which specialise in Norwegian craft: KODE Art Museums of Bergen, the National Museum of Art, Architecture and Design in Oslo, and the National Museum of Decorative Arts in Trondheim.[1] There is therefore no shadow of doubt that the Fund is one of the most significant institutions for the field of Norwegian craft today. In addition to its immense contribution to the field, it ultimately has an impact on Norwegian heritage and the nation's cultural value.

History

INK's establishment was the result of a congruence of interests between the three museums of decorative art in Norway, on one hand, and the Norwegian Association for Arts and Crafts (*Norske Kunsthåndverkere*,

1 In 1990, when INK was established, the names of the three participating museums were the West Norwegian Museum of Decorative Art (*Vestlandsk Kunstindustrimuseum*), the Museum of Decorative Arts and Design in Oslo (*Kunstindustrimuseet*), and the National Museum of Decorative Arts in Trondheim (*Nordenfjeldske Kunstindustrimuseum*). While all three museums are now part of massive consolidated museums, the National Museum of Decorative Arts in Trondheim, unlike the other two, has kept its individuated name.

NK) on the other. All these institutions strove to secure an important – but in many respects neglected – part of the visual field of art, namely, contemporary craft. In 1990, the Ministry of Cultural Affairs bent its ear to the requests from NK and the three museums and came up with a joint solution. Since then, INK has had a mandate to make autonomous decisions with respect to buying contemporary craft for KODE Art Museums of Bergen, the National Museum in Oslo and the National Museum of Decorative Arts in Trondheim. These are the only Norwegian museums with particular expertise in the field of contemporary craft.

Structure

Today, INK operates as a seven-member committee (also called a work group). Four members are professional artists: one represents the field of metal art, the second represents ceramics, the third represents textiles and the fourth represents glass, wood and leather. The other three members are representatives (usually academically trained scholars and curators) from the specified museums. Their involvement in the committee is a duty that comes as part of their regular professional job description.

As a craft artist, it is a great honour to be selected as a member of INK and to represent the interests of other craft artists for the four year period. You are selected for the post at the Norwegian Association for Arts and Crafts' (NK's) annual meeting. You therefore have a serious and professional responsibility to represent not only the interests of your own colleagues and other craft artists, but also the interests of the wider field of contemporary craft.

The artists in the committee have four-year posts (every second year two new artists are appointed), while the museums representatives are members for as long as their respective employers decide – often for more than four years. The long-term posts create stability while the short-term posts create change. Each member is fully aware of this responsibility and performs his or her duties in a serious way, exercising professional integrity and respect. Based on my own three years of experience as a member of INK, I am convinced that the structure and the mix of long- and short-term posts functions well.

Collective competence

The collective competence (the knowledge and skills of all the members) and the group dynamic, which necessarily includes friction between

Anne Guro Larsmoen: *SYMPATRIC SPECIATION (APPARATUS I, II, III, IV, V).*
Installation. Glass, metall. 2016. In the collection of KODE – Art Museums of
Bergen. Photo: Anu Vahtra

Kristin Opem: *Uten tittel (Untitled)*. Vase. Ceramics. 2016.
In the collection of the National Museum.

the independent artists and the museum scholars, provide a platform for healthy dialogue. This means the fund functions as a key forum for the contemporary craft discourse. It is a meeting place for professional craft artists and scholars that ensures the development of a balanced body of knowledge within the field. It results in members being able to discuss, evaluate and make relevant acquisitions that can complement the museum collections. The system, however, can only work properly if all the members have deep respect for each other's competencies. They must also share a common goal: to make interesting, relevant and high-quality craft acquisitions for the museum collections.

Exhibition schedule and visits

In order to visit as many exhibitions as possible, it is necessary to make an exhibition schedule in advance and to be open to revising and adapting it to the constantly changing field of craft. All the members are involved in this important task. It is of great value that the artists can, and do, use their time and networks in the wider field of craft to investigate exhibitions and artists. Without this investment of time and effort, INK as a working group would have fewer possibilities of staying abreast of what is happening in the field, of finding out about exhibitions, visiting them and evaluating artists' works.

Each year the group visits approximately 160 exhibitions in Norway (even Svalbard is included in the scope). It is unfortunately impossible to visit all the shows, but the members still do research on the ones they do not see. It is therefore very important that galleries and artists send exhibition information and photo documentation to INK. This information is accumulated and evaluated, and when the opportunity arises, INK members make new efforts to see the given artist's production. INK buys on site, in actual exhibitions. When a purchasing decision is being made, there is equal weight between the vote of the artist who represents the specific field of craft and the vote of the specific museum representative where the work would end up; thus both must agree on the purchase.

INK's purchases

INK's purchases vary in nature: they can be object based, site-specific installations or even time-based works. The primary goal is to purchase those works perceived to be the most relevant craft at whatever time in the ever-changing field of craft. After a work is purchased, it is sent to

one of the three museums and administered by that museum as part of its own collection. INK is obligated to provide public information about its purchases. All the basic details of its purchases are therefore available on the webpage www.innkjopsfondet.no.

Conclusion

In sum, the collaboration between artists and scholars is extremely fruitful in providing an optimal setting for buying high quality contemporary craft as well as for discussing contemporary craft in a constantly changing field.

Due to its structure, INK is able to avoid the pitfalls of becoming a powerful and biased cadre of decision makers who promote their own interests and those of their closest colleagues. The potential abuse of decision-making power is constantly addressed through the dynamic discussion between the members. They have mutual respect for each other's competencies and freely share their knowledge and insight with each other. These collective efforts result in the acquisition and preservation of relevant contemporary craft. They succeed in acknowledging the field of craft as an important part of the visual art scene and an important part of the Norwegian state's cultural value.

Franz Schmidt: *Weaving Fabrics for Suit – Roald*. Installation. Textile.
2015/16. In the collection of Nordenfjeldske Kunstindustrimuseum.
Photo: Anne-Line Bakken

Marius Engh: *Untitled (Gates)*. Sculptur/wall piece. 2006.
From the apartment of Petter Snare. Photo: Elisabeth Aarhus

Turn Your Gaze:
About Collecting on the Periphery

Petter Snare

It was the best of times, it was the worst of times, it was the age of wisdom, it was the age of foolishness, it was the epoch of belief, it was the epoch of incredulity, it was the season of Light, it was the season of Darkness, it was the spring of hope, it was the winter of despair, we had everything before us, we had nothing before us, we were all going direct to Heaven, we were all going direct the other way...[1]

The opening of Charles Dickens' *A Tale of Two Cities* seems strangely fitting as a description of what it is to collect art anno 2016. Never before has the supply been greater: the amount of art available to collectors is enormous. At the same time, there is a deluge of bad art and kitsch. New prophets are constantly claiming to have found the new wine, and art that can't be packed in bubble-wrap (because the paint isn't dry) is being re-sold again, only a few weeks after being purchased in the secondary market, and for fantastic sums. Before the market adjusts itself. Last season's 'early blue chip' is today's 'over valued'.

Collecting art has therefore become an ever increasing, and yet an ever-more-restricted, professionalised hobby. The group that needs art as a middleclass social marker has grown enormously, and the time when definitive judgments of taste were made by the likes of the art dealer Joseph Duveen, the expert Bernard Berenson or the connoisseur Peggy Guggenheim are perhaps over. Everyone is clearly (on his/her own) an artist/curator/expert.

So how can you find your own collection when the art compass's geographical north is constantly moving and the map is outdated? I think you have to stop trying to be a collector. It's become too difficult and perhaps too pretentious. It should be left to professionals, more or

1 Charles Dickens: *A Tale of Two Cities* (London: Chapman & Hall, 1859).

less, those with time and money, or perhaps only money, and room in their own museum. If you have that, you can be an art collector. The rest of us should make due with buying art, and with finding out how the works we acquire relate to our own lives.

I started out collecting contemporary craft. It was non-alienating, achievable. It was art I could touch – and perhaps use. Craft avoids the normal criticism that visual art is subject to, of being coded or difficult to understand. And because not just anyone can claim they could have made the object, you avoid feeling the need to defend it. An important point when you're trying to be a collector. Some of my earliest purchases were from the ceramic artist Irene Nordli, and eventually from Torbjørn Kvasbø. I still love craft and think each and every good collector needs it – reflections on material, form and spatial aspects force their way forward in ways that differ from reflections on visual art, even though the boundaries between the art forms are on the verge of being erased, as Edmund De Waal and Grayson Perry show.

After collecting a certain amount of craft, I was carried further and captured by the need to own art purchased through a skilled gallerist. I bought photos by Per Barclay and Hedevig Anker, and a video by AK Dolven. I also purchased works through other sources, at student exhibitions and auctions. Buying art is a spiral leading you towards expressions you were unaware of – and gazes so *other* that the magnetism becomes too strong. After the video work, I bought a number of installations by Tom Burr, wall works by Matias Faldbakken and audial works by Marit Følstad.

Still, it was difficult to orient myself without a framework. So photography and painting to some extent took centre stage. Christopher Williams, Fredrik Værslev and Ole Jørgen Ness are important to me. Their works confirm my passion and personal references and are like benchmarks.

Eventually, as walls and floor space fill up and storing and caring for the art become a not-insignificant expense, why do I continue to collect? Why are all my vacations and spare time used on art? Even to see a lot of art I'll never be able to afford – or would even think of buying?

I think art is more important than wall space. That's why I continue. The works accumulate in the storage facility and in apparently permanent interim-zones at home. But if I believe art is important, I must continue to buy.

Purchasing and surrounding yourself with art of course offers the enduring possibility of training your gaze, of seeing if a work gives of itself again and again, with each new perspective and insight, and through daily exposure. Sometimes a work loosens its grip and you find yourself finished with it. Both parties want to engage with new conversation partners. Other works never let go. But art also gains importance as representation. In a world where fiction seems increasingly to be dressed up as news, where faith becomes a tool for creating uniformity and were Newspeak becomes a legitimate medium for communication, art is essential. Art becomes the thing that forces us to stop and evaluate what we hear. Is this important, is it central, do we have room for an existence that exceeds the norm? All art forms contribute to this, but for me, visual art offers the greatest challenge. In visual art's potentially brief moment for consumption, there lies what is for me the greatest opportunity for reflection. So the conclusion must necessarily be that *if* art is important *then* it must be more important than a lack of wall or floor space. So let my small repayment to the art scene be to support those who work there, by continuing to buy art.

Art collectors also form a clan of sorts. The social and intellectual aspects of collecting should not be underestimated. It goes without saying that art becomes a social marker. It requires a certain income, even if not as much as many people think. But to be part of an environment that for the most part is very generous is truly rewarding. And to surround yourself with art challenges you always to seek to know more about what you see, to put it into a context. Just in general, to understand what you're seeing. For a lot of contemporary art, the rhetoric about the work is absolutely central, but, at the risk of stressing the banal, it's a misunderstanding to think that a work is completely 'digested' simply because you see recognisable elements on a two-dimensional surface or in a three-dimensional form.

Strategies for buying art

Given the limitations, or opportunities if you will, which strategies do I use for buying art? Is there a strategy at all? Well, if it's not a strategy, it's at least a type of thinking or maybe an attitude. My personal preference is for works with a strict aesthetic. Much of what I buy therefore tends aesthetically towards the minimal. This can hardly be called a strategy, but it moves in that direction. When the price level for quite a bit of art, even relatively small works, approaches the equivalent of

several years' salary, you need to find alternative approaches to purchasing. I try to be loyal to certain artists, as long as my financial situation and their prices make that possible. Now and then I try literally to see beyond the frame of the conventional. It's possible to build a fine collection of wall works, videos, installations, etc., artistic expressions that are more challenging than the usual. The brave can be rewarded by buying early in an artist's career, or before the artist is well-established.

I think also that not all the works need to be masterpieces. Building a collection involves more than just buying *Artforum's* top ten. It's also about showing how the works fit into the context of your life. In this respect, drawings and collages, photos in editions and prints can be fantastic. A collection without a distinctive, individual character is a boring collection. It's in the unusual that a collector's eye comes to expression.

I like going to art fairs and galleries, and I try to support every stage in an important chain of creative production (extending from the artist to the gallerist, the catalogue publisher, and so forth). I try to collect from the entire contemporary field of both visual art and craft. But now and then I also find just the right works by artists from earlier generations. Contemporary photography obviously has references back in time. Today's painting has important contrasts and presents a learning curve that adds depth to the reading of new works.

Now as I review my never-updated list of works, I see that what I imagine to be a coherent collection in a limited range of media may actually lean towards being a somewhat random collection of all manner of expressions from several periods. Still, it's possible to see that it has a direction, and that many of the purchases can at least be defended in a credible way.

So in reality, the only strategy for collecting is that you know yourself well enough to be able to allow yourself to be challenged. Buy what you don't immediately like. See qualities you haven't noticed before. Go from the known to the unknown. Turning your gaze can therefore be as good a strategy as any other.

Matias Faldbakken: *Shocked into Abstraction*. Wall painting. 2009.
From the apartment of Petter Snare. Photo: Elisabeth Aarhus

Hanne Borchgrevink: *Husdikt 5*. Painting. 2010. Jan Groth: *Tegn IV*. Textile. 1989.
From the apartment of Petter Snare. Photo: Elisabeth Aarhus

Owen Bullett. *Divided Self II*. Cedar, painted steel (90 x 45 x 180 cm). 2012. Photo: Philip Sayer, courtesy of Marsden Woo Gallery. The Anthony Shaw Collection/ York Museums Trust

The Anthony Shaw Collection:
Passion for a Collection

Anthony Shaw

I should start by saying that I never planned to make a collection, but looking back, it seems to have been my destiny. It almost did not happen but for two artists who I met in 1976: Ewen Henderson and Gordon Baldwin. I started collecting in 1973, although I had been very aware of and interested in it from the late '60s and onwards. I say 'almost did not happen' because soon I was tiring of perfect pots and of being concerned mainly with form, glaze and craft. Ewen and Gordon introduced me to the art rather than the craft of ceramics and clay as a medium, and it completely changed my outlook. Since then, I have joined with them on their journeys as they developed, acquiring a large number of works by both artists. This has influenced my selection of other artists' works, which I have been adding to the collection since the late '70s. It has also affected my method of following particular artists throughout their careers.

My passion for clay started early, through picking up potsherds in Roman remains and making many visits to museums abroad. I was intrigued by the ability of clay to capture the character of the maker, and then the firing sealing it in forever. My journey was greatly helped by a family friend, Henry Rothschild, who started the craft gallery Primavera in London in the mid-1950s. He inspired me with the idea that you could live with art and that ceramic works were very inexpensive – they remain the most undervalued art form. In fact, my first pot came from Henry. He put on an exhibition of German crafts in 1973 at Kettle's Yard in Cambridge. I liked a silk wall-hanging by Lotte Hofmann, and when he noticed my interest in some of the pots, he offered one as a discount if I bought the hanging.

I had very limited funds when I started collecting, so I decided that a good way of getting to know the artists I liked and to buy directly from them was to offer them small exhibitions in my workshop windows. I did this from 1976 to 1981. After 1981 I felt there was no longer anyone

whose works I wanted to show. Looking back, I was very surprised to note that I had not added works by a new artist to the collection for about a 16-year period, starting from 1980. I had not noticed this because I had more than enough new and interesting work from the small group who by then included Gillian Lowndes, Bryan Illsley and Sara Radstone.

Looking back, the early '80s was a particularly important period for the artists I liked. Ewen Henderson had started to collage sculptural pieces that echoed his interest in standing stones and skulls. Gordon Baldwin started his 'developed' series with flanges that provided areas to paint, a journey he has continued, describing a universal landscape of modernism. Gillian Lowndes found her true métier of mixing everything she could with clay. The sculpture of materials, drawn with sensitive eloquence. Bryan Illsley had decided that he needed to concentrate on his art, so he moved to London, leaving Cornwall and his jewellery partnership with Breon O'Casey. Painting was his principle aim, as it is today, but sculptures made in many mediums have extended his exuberant vocabulary. Sara Radstone had just left Camberwell and was starting her journey of finding her forms of expression. Although individually very different, there are to my mind subtle connections between these artists. To quote Ewen, their works are 'word proof', expressing so much more than can be put into words.

I am drawn to the very physicality of clay. I need to touch and be in the presence of the works I buy. I am shocked that so much collecting is done online now, perhaps because what interests me is not how a work looks. The qualities I seek do not photograph well. We are becoming separated from the 'real' thing, and less able or concerned to understand the physical. I started collecting when hand building was a strong movement; now it is slip casting and transfer printing. Next is 3D printing. This seems to be making a complete break with ceramics. The results might as well be made of plastic. It depresses me that this is happening, and few people question whether it is a good thing. It is clean and much cheaper, none of the reality of clay between the fingers, and can be setup to print while the creator sleeps! For me it is totally alien, and not in a good way. I seek out the 'otherness' of things, but they must have a human or animal spirit and defy being printable.

My collecting has been instinctive and I am drawn to works that only slowly disseminate their meanings. Most of the ceramic artists that are represented in the collection started out as painters, and I feel

their work is 'painting in another form'. It has the freedom that comes with the process of making with no clear idea of how the piece will finally emerge. This freshness is vital: the emotions contained in a work are so much more important than how it looks. We live in such a visual age, everyone looking at screens all day. I am not concerned with the 'look' – it's the 'feel' that is all important.

My early years as a collector were very different from the situation today. There was much enthusiasm from a band of collectors, and there were interesting developments from one exhibition to the next. If you were able, you needed to view exhibitions before the private view (PV) in order to make decisions, as red spots appeared as soon as the PV started. Success generally fuelled the competition between artists, and the very reasonable prices attracted a large group of buyers. Nowadays prices are higher, although still low in comparison with other artistic mediums. Sales of what I consider the best and most challenging works are slow, so PVs are not the fraught affairs they used to be. My instinct is to commit early if I am interested, a habit from the early days.

Having such large groups of work from single artists, spanning many years, has become quite a responsibility. These pieces were never bought with the intention of selling at a later date, and the resolve not to sell any of them has only become stronger with time. I feel it is crucial to keep the collection together. I have puzzled over the years, about what would happen with it all in the future. This was brought to a head by the death in 1989 of Liliana Epstein. She had a large collection of ceramics (we shared two pieces), and it was all auctioned off because she had not made any plans. The timing was such that I made up my mind that setting up a charitable trust was the best way to protect the collection. I donated the family home to help fund it. I have had vital support from two great friends, Tatjana Marsden and David Whiting, who share my enthusiasm for this group of artists. They also helped mount the major Gordon Baldwin exhibition at York Art Gallery. Tatjana is Baldwin's dealer and has been selling his work since the early 1980s, and it was around that same time that Liliana introduced me to Tatjana.

The terms for gaining charitable status entail displaying the collection to the public. This started in 2004, in the small terraced cottage on the edge of Chelsea in London, the former family home. It was the first time I had space to show the collection, and in a way, the first time I really started to get to know it. A very important aspect of

showing and living with this art is that it should fit naturally into a domestic setting. We had changing *Selections*, made by guest curators, and with each one, I learnt more, seeing the collection through their eyes. Works were displayed on antique furniture, not on plinths which I hate, or they were set against books and pictures, so there was a dialogue between the works themselves and between the works and the room as a whole.

In 2009 we decided that the collection needed to be more accessible to the public. The timing turned out to be perfect, since the Gordon Baldwin exhibition *Objects for a Landscape* was being planned for York Art Gallery, and Janet Barnes, the CEO of York Museums Trust, was planning a major redevelopment of the gallery, opening up a hidden space which now houses the Centre of Ceramic Art (CoCA). She was a great friend of the trust, supporting us for charitable status, and understood the importance of displaying the collection as it was in Billing Place, London SW10. I asked her in late 2009 if the gallery would like to have the collection on the understanding that it would be displayed in a domestic setting. Her immediate agreement has made it possible to give the collection the new home it has today.

I continue to buy, though I feel it is another fallow time similar to the early 1980s. Two new artists, Nao Matsunaga and Kerry Jameson, excite me as much as Ewen and Gordon did at the beginning. They remind me that I am after the truly original, the work that cannot be copied.

Nao Matsunaga. *Unknown, Unnatural, Unreal I*. Glazed ceramic, stone, acrylic paint. (18 x 23.5 x 13 cm) 2015. © Nao Matsunaga. The Anthony Shaw Collection/ York Museums Trust

Nao Matsunaga. *Good Plan Gone Bad*. Ceramic. 2015. Photo: Philip Sayer, courtesy of Marsden Woo Gallery. The Anthony Shaw Collection/York Museums Trust

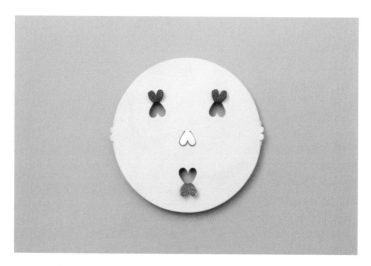

Otto Künzli: *Freund*. Brooch. Metal, paint. 1998. Photo: Rob Bohle

Robert Elsaesser: *Ring*. Goldplated silver, porcelain. 1996. Photo: Rob Bohle

Thoughts on Colleting

Paul Derrez

Building a collection is much like living life or writing your autobiography
– it is intensely personal.[1]

Every one of us is a collector, whether we want to or not: we all save
messages and photos on our phones and computers. We 'store' them
in folders in order to retrace them, and in doing so create huge virtual
collections of images that are compact, cheap, and always available.

Collecting actual physical objects is something entirely different.
Collecting stuff is a matter of choice and dedication and can become
a passion, an addiction even.

As a collector you can receive, swap, find or buy anything: sugar
bags, sneakers, egg cups, porn pictures, frog-figurines, shells, pieces of
art et cetera. Much 'pre-work' can be done on the Internet, and if you
collect through auction sites, all you need to do is press a button and
your newly acquired object will be delivered to your home.

Of course you can also go out to explore and judge the quality
and condition of objects in person. Specialised fairs and markets are
highly popular, and viewing days at auction houses draw lots of visi-
tors. A great many people feel the urge to keep adding to their chosen
fascination. Finding something new is always exciting. It's like playing
a game by a set of rules of your own making.

As the owner of Galerie Ra I promote and present artist's jewellery.
Ever since opening the gallery in 1976, I have met people who were –
or became – collectors of contemporary jewellery. Sometimes they
already collected antique or ethnographic jewellery, and discovered
'artist's' jewellery as a new area of interest.

Jewellery in general has ideal characteristics for a collector: it is
relatively small and therefore comparatively easy to carry and store. It

1 Erling Kagge: *A Poor Collector's Guide to Buying Great Art* (Oslo: Kagge forlag,
 2015).

gives its collectors opportunity to specialize and, for instance, collect pieces from a certain period, country, style or material, type, function or maker (or, obviously, combinations of those things). And last but not least: jewellery can represent a lot of cultural and emotional meaning and gives the wearer the opportunity to communicate that in public.

It usually starts with confrontation and surprise, followed by a developing fascination and preference, in its turn followed by deciding on a certain object and its acquisition. If the fascination intensifies and continues, other acquisitions can accumulate into a collection. This often happens without planning, until someone suddenly realizes that those twenty brooches actually are something.

Most European collectors I know went through a rather unstructured collecting process without any strategy, fuelled only by fascination and passion. During the Nineties a growing number of people started collecting with a specific plan, method and purpose, and with the possibility of a future donation of their collection to a museum in the back of their minds. I had seen this curator-like approach earlier on in American collectors, who let common interest and continuity prevail over personal taste and the spur of the moment.

Social responsibility has priority in the institutional collections from museums and foundations, though personal preferences of the people buying for those institutional collections always come into play.

Apart from their spending budget, important factors in museums and institutions are whether the budget is specifically intended to acquire jewellery, and whether it's nationally or internationally labelled. The Seventies saw several Dutch museums buying up innovative Dutch jewellery from that period, with quite similar collections as a result. Even now, many institutional spending budgets are nationally orientated.

Meanwhile, the jewellery market has become a very international scene and galleries are competing for the attention of a relatively small group of internationally operating collectors.

Collecting has become a very important factor in the 'market' of contemporary jewellery. Collectors generate money and are interested in and committed to the professional field. They converse about content, meaning, interest and quality amongst themselves but also with artists and gallery owners, thus indirectly influencing the development of the work. While the mainstream jewellery buyer is just looking for a pretty pendant or ring, collectors usually go for big brooches

and necklaces. As a consequence there are many big brooches and necklaces being made by artists who wouldn't dream of wearing such pieces themselves.

My husband Willem Hoogstede and me have been collecting jewellery since 1975. The start of the collection was the jewellery I had to finish and assemble during my internship, for which I was paid per piece. I wanted to be paid in jewellery. After opening Galerie Ra in 1976, it has been tempting to buy works from every collection on show, in honour of the artists, but also as souvenirs of those particular moments. Obviously I didn't always have the funds to buy something, but there were occasions when I could swap if the other artist took a liking to my own work.

At first we bought jewellery with the intention to wear it ourselves. As our collection grew, this aspect became less important. We usually come to a quick agreement on what to choose, and never harbour any doubts afterwards. Back in the day we also collected other objects: ceramics, hats and fans. After our first visit to Beijing we returned with fifteen Yixing teapots – we own about fifty now.

During the past forty years we regularly exhibited pieces from our jewellery collection. A highlight was the exhibition *Dare to Wear* in the CODA-museum in Apeldoorn in 2013, with a selection of five hundred pieces of jewellery from the years 1966–2013 (we had also collected pieces made before 1976). This very diverse collection was shown on large panels in a display-case of thirty meters long, and grouped by type of jewellery, period and sometimes maker. Creating a good overview wasn't easy, but interacting with all those beautiful things was a pleasure and gave much contentment.

After this mega-presentation we put out smaller selections from our collection in other exhibitions elsewhere. About twenty-five pieces of Dutch jewellery from the Seventies have been included in a current exhibition about the Seventies, along with the collection of badges with a political message that we started towards the end of that decade. We were interested in those messages and in the way they were visualised. The shape of the badges was a given, and they had no intrinsic value.

Still, this collection became a meaningful document as it mirrored the political and societal controversies of the period.

A selection of jewellery that illustrates the forty year-history of Ra Gallery has been on display at the Sieraad 2016 fair.

We haven't yet decided what will happen with our private collection after our demise. At first we considered donating everything to a fine art museum that also specialises in jewellery. This option has lost some of its attraction upon learning that with a changing of the guard, museums may suddenly change their priorities. Also, museums no longer accept complete collections but prefer to pick the jewels from the crown.

Most collectors worry about the prospect of their precious collection falling apart. It is a pressing dilemma for many aging collectors, which is why a new Dutch initiative came into being: the Stichting Sieraden Collecties (SSC, Foundation for Jewellery Collections).[2] The foundation wants to create and guarantee a kind of home for jewellery collections, describe them, conserve them, and present them to the public. It aims to keep jewellery as its key objective, to respect collections in their entirety, and to strive for continuity. The initial distrust collectors felt towards the initiative is now slowly dissolving.

It will take some effort to realise the objectives though. There is hardly any money to describe and conserve the work, let alone for establishing a decent archive and organising presentations. Hopefully it won't take too long for the initiative to become solid, because once the collectors have passed away, the transfer of collections – and knowledge – will be much more difficult and complicated. One of the nice things about the initiative is that it targets jewellery in general: not just artist's jewellery but also historical, ethnographic and costume jewellery. This is a consequence of the common practice of collecting where collectors build several jewellery collections at once. Inherently, this diversity will enable the SSC to reach a wider audience. By now, the first pledged collection is acting as a pilot case.

A successful example of the transfer of a private collection to a museum is the donation by Marjan and Gerard Unger to the Rijksmuseum Amsterdam. In consultation with conservators of the museum, they selected five hundred pieces of Dutch jewellery from the twentieth century. The museum didn't own any jewellery from that period and could fill this gap in one go because of the generous donation. The fact that the Unger collection emphasised the cultural meaning of jewellery rather than its art-historical interest suits the position of the Rijksmuseum perfectly, as its priorities lie with national history.

2 Editor's note: Liesbeth den Besten discusses this in her essay in this book.

An additional advantage of donating a collection to a designated institution, is a tax benefit, divided over a period of five years.

Again, it's a dilemma, but that shouldn't stop anyone from collecting whatever jewellery he or she takes pleasure in. Jewellery mirrors its zeitgeist, conjuncture and fashion. It enriches our everyday lives, everyday.

Josh Faught: *The Mauve Decade*. Fiber and mixed media. 2014.
As installed for Launchpad in London. Photo: Noah Da Costa

Off the Shelf

Glenn Adamson

If you have spent any time with collectors in the craft field, you will be familiar with the sight. Walls that in some homes might be given over to paintings or flat-screen televisions are instead bedecked with tier after tier of objects. The medium doesn't much matter. Ceramics, glass, wood, basketry and metalwork are all well set-off in such arrangements, often enhanced by bespoke lighting. Jewellery gets a similar treatment, inside cabinets with many drawers.

These collections tell many stories at one and the same time. There are, of course, questions related to the collector's eye: What do collectors' selections say about them? Do they stick to just one material or do they mix it up? Do they go far afield, introducing historical artefacts in amongst the contemporary? Do they install the works according to a simple system (red things on one shelf, blue on another) or is there a more complex and subtle rhythm?

Then there are other questions that say as much about collectors' social proclivities as their aesthetic ones. Do they go in depth and collect works by only a few people, as a way of supporting those artists' creative vision, buying as a way of giving? Or do they spread the wealth, perhaps maintaining greater objectivity? How scholarly are they? When you ask them about their holdings, do they remember every name, not just the artists but the galleries where the work was purchased, or what that special wood or glaze is called? Can they describe why an object is important, and not just why they like it?

These questions lead in turn to another set of questions and still larger narratives. If you add up all the contents of all the shelves of all the collectors, you can see how the studio craft movement shifted from its countercultural origins and expanded into a full-blown market phenomenon. It happened piece by piece, price by price, onwards and upwards. Without these private repositories – assembled in rough approximation to the logic of museums, but shot through with a deep sense of the personal – far fewer makers could have made it as professionals. And the field would look much different than it does today.

The shape of the crafts today, however, is not only about what finds its way to the shelves. It is also the result of what doesn't fit there. Much concern has centred on craft's uncertain status in relation to fine art. But what really dictates the flow of opportunity has as much to do with accommodation as it does with ideas. A few of the major craft categories, such as furniture, stained glass, and blacksmithing – anything that tends to be large in scale – cannot easily be accommodated in the traditional collecting system. As a consequence, artists working in these areas have struggled to achieve the kind of market success that more tidily arranged media have enjoyed. There are other ways, of course, and makers in these areas have subsisted (occasionally thrived) on commissions – dining sets, windows, gates, chandeliers. But there is little doubt that it is a tougher road.

Meanwhile, other craft fields that tend towards the large scale, such as fibre art, have operated in ways more akin to the wider art market. Only a few big names make a success of it, sometimes via alternative patronage structures (including public art and ecclesiastical commissions). Conceptually, fibre artists are no more inherently allied to fine art than are their colleagues in ceramics and glass. But because it is literally harder to 'place' their work in homes, they have had to adopt strategies more suited to the museum.

These dynamics are not unique to craft. There is an unwritten law in the auction business that paintings are easier to sell than sculptures (and that paintings that fit into an apartment building's freight lift are the easiest). But in the case of craft, there is a special dilemma that results from the logistics of display: the experiential and political dimensions of the handmade tend to be absent from collectors' shelves. In my own work, I have often sought to emphasise the meaning of craft as a verb, not a noun. For me, the key issue is how the world around us is made.

Craft, in this context, stands for a more thoughtful and informed way of shaping the environment. But you cannot buy a verb and pop it on the shelf. This has led to an acute conflict between the traditional means of supporting studio crafts and the philosophical intentions of the movement. That gap has led to an overwhelming emphasis on craft processes that lead to buyable goods, rather than on the many worthwhile skills that reshape our world in other, perhaps more profound ways.

If we want to realise the potential of craft in the twenty-first century, then its economic underpinnings need to evolve. Arrangements

of one beautiful object after another can be wonderful in and of themselves, but they do not deliver the support that craft in its full breadth requires. Add to this the fact that traditional collectors, the generation who began actively acquiring in the 1980s and '90s, are not being replaced by younger patrons, and you have a difficult problem – so difficult that radically new creative strategies are called for. Makers are seeking new applications for their skills, ranging from 'relational' social projects to digital experimentation.

Collectors have an equally important role to play. Traditionally, they have been a conservative force in the crafts, oriented towards the noun rather than the verb. Their motivations have certainly been worthwhile: the recognition of well-made and beautiful things, and support for those who make them. This generous attitude has provided the studio movement with a vital anchor and badly needed, consistent stability. But now there is the potential to chart a new course. This involves developing not just new approaches to display, but a whole new set of motivations.

Twenty-first century collectors may be less moved by their own personal aesthetics as by a deep understanding of artistic intention. They will also, quite likely, take a broader view of craft, seeing it not in medium-specific terms but as a pervasive force in art and design. This means they will be aware of the art world at large, not just a few galleries and museums, and will be willing to act as competitive consumers in the contemporary art scene. For better or worse, the intimate, everyone-knows-everyone dynamic that is typical of the crafts (which encourages allegiance, but discourages critique) will gradually give way, in favour of a more challenging, less shielded situation.

How can a collector best navigate these wide-open waters? Ironically, the best way is to focus, creating a situation in which a single artist's viewpoint is given full room to express itself. One simple and increasingly common way of doing this is to commission an installation. In this case, the artist not only produces objects but also a holistic environment for their display. There is nothing conceptually new in this; it is essentially an expansion of the longstanding practice by which bespoke décor is created for homes. But insofar as it necessitates a conversation between maker and owner, there is potential in such arrangements to achieve a deeper aesthetic and conceptual register than the traditional decorating or *objet d'art* approach.

The results can often be superior to what an artist can achieve in a gallery, particularly in the context of craft, as the opportunity to work site-specifically in a domestic interior often resonates with the materiality and typology of the handmade. Ideally, a collector considers every aspect of his or her everyday environment as an opportunity for aesthetic connection. Small scale craft-based enterprise is flourishing in our time and provides plenty of opportunity to realize an updated version of William Morris's famous axiom: have nothing in your home that you do not know to be useful or believe to be beautiful.

Public institutions also have a role to play. Museums set in historic domestic interiors (like Kettle's Yard in Cambridge, Chatsworth, the Freud Museum, or the John Soane Museum) have become increasingly active in commissioning craft-based installations, thus modelling possibilities that contemporary collectors can adapt. There have also been adventurous curatorial souls who have proactively positioned art in the private realm, such as Colin Painter, whose edited volume *Contemporary Art and the Home* (2002) remains an essential reference.

Slowly but surely, new and innovative strategies are beginning to emerge. One example is Launchpad, conceived by London arts patron and curator Sarah Elson. In this initiative, the collector not only commissions a work but also houses the artist for a period of time while the work is being developed. Upon completion, the home is temporarily transformed into a gallery: artist talks are staged in the space, and the press and visitors are invited to view the work. In the process, the polarity of ordinary collecting activity is reversed. A private artwork serves as a focal point, almost an excuse, for public interaction and exchange. This scheme involves some operational delicacy, including the co-habitation of artist and patron, and the crossing of the public/private barrier. But the model has some momentum. Launchpad has now had its first manifestation in New York City, and it has the potential to become a more generally observed practice.

This is just one example in which the stance of the collector is hybridising with other roles, including those of the dealer, philanthropist, and curator. As craft practice itself becomes more elastic and exploratory, collecting will need to do the same in order to keep up. Beautifully installed shelves of objects will likely always have a place. But the leading collectors of our field will indeed be those who find ways to capture craft in motion – incorporating prototypes, videos, installation art and bespoke environments of all kinds into their lives.

In the broader realm of contemporary art, this experimentalism is just what one might expect. Craft collectors can follow suit, in part, simply by being more open-minded about what they live with and how they live with it. But they can also do more than that. The natural emphasis in craft is on creative processes, on objects in the moment of their making, on the raw as well as the cooked. That makes the field ripe for experimentation in a way that is unique and connects deeply to the human dimension of creativity. It points to a thought often expressed, but worth repeating: if you really love something, the best thing you can do is to set it free.

A selection of works from the home of Allan and Joy Nachman in Bloomfield Hills, Michigan. Photo: Addie Langford

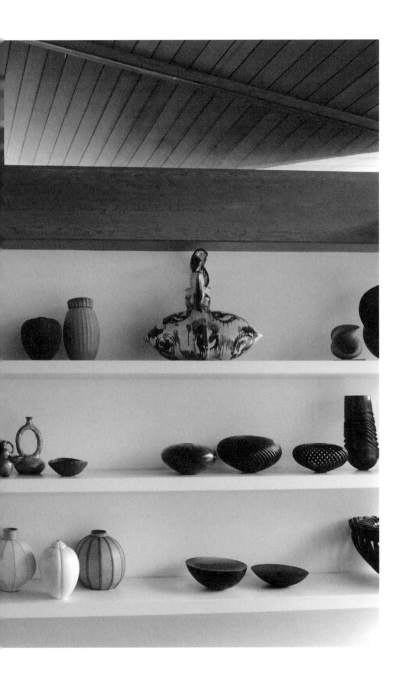

Contributors

EDITOR

Andre Gali is head of critical theory and publications at Norwegian Crafts and series-editor of *Documents on Contemporary Crafts*. Gali is also founding editor of the Nordic art quarterly Kunstforum and the website www.kunstforum.as, founded in 2009. Gali was editor of Kunstforum until 2015. Today he is Senior Advisor at the recently established Kunstforum Consulting. He holds a Master's degree in theatre theory with a thesis entitled 'Andy Warhol Superstar: *On the Artist Myth, Media and Mechanical Theatricality*' (2005). Gali has worked as a freelance art critic, photographer, essayist, journalist and lecturer, and has published essays on art and economy, queer and feminist art practices, the gaze of the middle class, and contemporary art jewellery. Recent catalogues and books he has contributed to are: *Fornebu Art and Architecture Destination* (2017), *Kampen med materialet – Norske Kunsthåndverkere i 40 år* (Editor, 2015, Norske Kunsthåndverkere), *Crafting Exhibitions* (editor, 2015, Norwegian Crafts & Arnoldsche Art Publishers), *Reinhold Ziegler: Cosmic Debris* (2014, Arnoldsche Art Publishers), *Aftermath of Art Jewellery* (2013, Arnoldsche Art Publishers), *Museum for Skills* (editor, 2013, Norwegian Crafts), *Morten Andenæs: Skyldfolk* (2012, Teknisk Industri), *Never Mind The Benefits* (2012, Feil Forlag) and *Sigurd Bronger: Laboratorum Mechanum* (2011, Arnoldsche Art Publishers). Gali has been on the board of the Norwegian Critic's Association (2009-2011) and leader for the art section at the Norwegian Critic's Association (2010-2012).

WRITERS

Glenn Adamson is currently Senior Scholar at the Yale Center for British Art. A curator and theorist who works across the fields of design, craft and contemporary art, he was until March 2016 the Director of the Museum of Arts and Design, New York. He has previously been Head of Research at the V&A, and Curator at the Chipstone Foundation in Milwaukee. His publications include *Art in the Making* (2016, co-authored with Julia Bryan Wilson); *Invention of Craft* (2013); *Post-*

modernism: Style and Subversion (2011); *The Craft Reader* (2010); and *Thinking Through Craft* (2007).

Liesbeth den Besten is an independent art historian who is working internationally as a writer, curator, advisor, jury member, exhibition maker, teacher and lecturer in the field of crafts and design, especially contemporary jewellery. She has curated exhibitions for different museums in the Netherlands and abroad. She is chair of the Françoise van den Bosch Foundation www.francoisevandenbosch.nl, and member of the AJF board www.artjewelryforum.org. She is the author of *On Jewellery*, a compendium of international contemporary art jewellery (Arnoldsche 2011, reprinted in 2012) www.arnoldsche.com, and has contributed to many publications. She teaches jewellery history at Sint Lucas Academy in Antwerp.

Paul Derrez is the driving force behind Galerie Ra in Amsterdam. The gallery has been an important advocate for contemporary jewellery design worldwide since 1976, and promotes the work of artists such as Peter Bauhuis, Lisa Walker, Sigurd Bronger, Warwick Freeman, Karl Fritsch, Tanel Veenre and Noon Passama. Derrez is also a jewellery designer himself and has background from design studies and goldsmithing. He has won several awards for his works, among them the prestigious Herbert Hofmann Prize 2015. His works can be found in many museum collections, among others in Stedelijk Museum, Amsterdam (Netherlands), The Museum of Fine Arts, Houston (US), National Museum of Modern Art, Kyoto (Japan) and Nordenfjeldske Kunstindustrimuseet, Trondheim (Norway). Since 1975 he has, together with his husband Willem Hoogstede, built an important collection of contemporary jewellery consisting of more than 500 pieces.

Trude Schjelderup Iversen is a curator, art theorist and critic. She is the previous director of UKS, Young Artist Society (2001–2005). She has a Ph.D. Candidate in art theory (University of Oslo 2007–d.d), and has been a curatorial resident and lecturer in contemporary art theory at Center for Curatorial Studies, Bard College, New York (2008–2009). Her writings has appeared in numerous journals, periodicals, catalogues, magazines and books including *Lights On* (Astrup Fearley Museum), Red Hook Journal (CCS Bard College) *Capital it Fails us Now* (edited by Simon Sheikh), *Art and its Institutions* (edited by Nina Montmann).

Her own publications include *The New Administration of Aesthetics* (Torpedo Press 2007) co-edited with Tone Hansen, *Critical Issues in Public Art – The Reader* (2016) co-edited with Nora C. Nerdrum and *Migration and Architecture* (fall 2016). She works as a curator at Public Art Norway. She was the initiator and programmer of the lecture series *Critical Issues in Public Art*, KORO, a much visited platform for discussing current conditions for art in public space today. Current curatorial projects include a new public project with American artist Suzanne Lacy; a collaboration with KORO and Henie Onstad Kunstsenter to be realised in Bærum, Norway in 2018. *Migration and Architecture*, a long-term collaboration with Norwegian artist Knut Åsdam consisting of three new commissioned works by Åsdam and a publication (2016). In 2015 Schjelderup Iversen was appointed curator for an art project initiated by the Norwegian Parliament. Focusing on the current idea and understanding of 'New Materialism' the project explores the legacy and rich tradition of Norwegian female artist who use textile as a main component in their art meant for public space.

Gunnar B. Kvaran was born in Reykjavik, Iceland, in 1955. He completed his PhD in the history of art in 1986 from the University of Provence in Aix-en-Provence. From 1983 to 1986, he was director of the Asmundur Sveinsson sculpture museum in Reykjavik; from 1986 to 1997, of the Museum of Modern Art in Reykjavik; and from 1997 to 2001 of the Museum of Art in Bergen, Norway. He was the curator of the Icelandic Pavilion at the Venice Biennale from 1984 to 1990. Since 2001, he has been director of the Astrup Fearnley Museum in Oslo. He has been curator for the Lyon Biennale in 2013 and co-curator for the 2nd Moscow Biennale of Contemporary Art, 2007. Recently curated exhibitions includes: *LOS ANGELES A FICTION*, September 2016, YOKO ONO, 'Instruction works', Mexico City, Buenos Aires, Reykjavik, 2016, *EUROPE, EUROPE* the European emerging art scene part 1. (together with Hans Ulrich Obrist and Thomas Boutoux), September 2014 and *IMAGINE BRAZIL* (together with Hans Ulrich Obrist and Thierry Raspail), 2013.

Dr.philos. Knut Ljøgodt is an art historian who studied at the University of Oslo, Courtauld Institute of Art, London, and the Norwegian Insitute in Rome. He received his doctorate from the University of Tromsø – Norway's Arctic University. Ljøgodt is an experienced insti-

tution leader and curator, and was the director of the Northern Norway Art Museum, Tromsø 2008–16, and formerly a curator at the National Gallery, Oslo. He is also founding director of Kunsthall Svalbard in the Arctic (2015), a space dedicated to contemporary art on an international level. During his years as director of the Northern Norway Art Museum, he focused on building the collection through acquisitions, commissions and donations, which secured the institution more than 650 works of art. Ljøgodt has curated a number of exhibitions and published several books and articles on Nordic and international 19th century, modern and contemporary art. His latest book, *Treasures* (2016) is about collecting.

Nanna Melland has more than 15 years of experience as a professional artist. She has participated in solo and group exhibitions, symposia, and workshops in Norway and internationally since 2001. Melland is the recipient of several prices, and a number of her works have also been bought by public and private collections in Norway and abroad. Her work is represented in a variety of publications. Melland teaches and gives lectures in schools in Norway and Europe. She has a broad, interdisciplinary education: Diploma from the Art academy in Munich; trained as a goldsmith at Elvebakken Technical School, Oslo; and Candidata Magister in history of religion and social anthropology from the University of Oslo. She has been selected for two positions as representative of the Norwegian Association for Arts and Crafts in the Committee of Public Art in Oslo, and as manager of the Norwegian Craft Acquisition Fund, the only national, state funded fund dedicated to collecting crafts.

Yuka Oyama was born in Tokyo and grew up in Malaysia, Japan, and Indonesia. She received her BFA (Jewelry and Light Metals) at Rhode Island School of Design in the USA and MA at Munich Art Academy (Art Jewelry and Sculpture) in Germany under the tuitions of Otto Künzli (Jewelry Art) and Asta Gröting (Sculpture). Since 2012, she has been an artistic research fellow at the Art and Crafts department at the Oslo National Academy of the Arts. Oyama adapts wearable sculptures that are enacted through performance, documented in photography and film, presented in installations. Oyama is fascinated by collectors and their relationship to the objects they own, and have used this as a theme in her own artistic practice.

Anthony Shaw has been collecting art for over 40 years. He is particularly drawn to work that explores the sculptural and painterly qualities of clay. Shaw design and make clothes for men and women. He is almost self-taught, leaving school (1968) a year early. Henry Rothschild gave him his first and only exhibition in 1969 in his Primavera shop in Cambridge. It was called 'Shirty Look' a collection of about 12 shirts which could be unisex. Shaw spent 1970 learning about cutting and working for a tailor, a piece-maker of jackets. Working from home he dressed a friend's wedding from which work flowed. He opened his workshop in 1971. Emptied it in 1975 to show 4 potters for 1 month. From then to 1981 had exhibitions in the workshop windows.

Petter Snare is an avid art collector with a collection comprising of more than 250 pieces of art. Snare is the board chair of kunstkritikk. no, an online art journal, *Bergen Kunsthall and Bergen Assembly*, in addition to being a board member of both the art fund *Bildende Kunstneres Hjelpefond* and *Akershus Kunstsenter*. Snare also runs publishing houses *Teknisk Industri* and *Uten Tittel*.

Dr Margaret Wasz, Consultant Psychological Therapist. Lives and works in Ireland.

Documents on Contemporary Crafts, No 4
On Collecting

Editor: André Gali
Contributors: Glenn Adamson, Liesbeth den Besten, Paul Derrez, Trude
Schjelderup Iversen, Gunnar B. Kvaran, Knut Ljøgodt, Nanna Melland, Yuka
Oyama, Anthony Shaw, Petter Snare, Dr Margaret Wasz
Translation, transcription, proofreading: Arlyne Moi, except the texts by Gunnar
B. Kvaran and Paul Derrez. Derrez' essay was translated from Dutch and edited
by Roelien Plaatsman.
Photography: © the artists/BONO
All texts © Norwegian Crafts and the authors

Thanks to: Trude Schjelderup Iversen and KORO (Public Art Norway)

Publication designed by: Aslak Gurholt (Yokoland)
Typeset in Tiempos Text 8.5/12.5
Printed on Munken Pure 120g, Arctic Paper, Sweden
Printed by: Livonia Print, Latvia

Publication funded by: Arts Council Norway

Bibliographic information published by the Deutsche Nationalbibliothek
The Deutsche Nationalbibliothek lists this publication in the Deutsche
Nationalbibliografie; detailed bibliographic data are available on the Internet at
www.dnb.de.

ISBN 978-3-89790-493-4

Norwegian Crafts
Rådhusgaten 20, 0151 Oslo, Norway
Phone: +47 22 91 02 60
Email: post@norwegiancrafts.no
www.norwegiancrafts.no

Arnoldsche Art Publishers
Olgastraße 137, D-70180 Stuttgart
Phone: +49 (0)711 64 56 18–0
Fax: +49 (0)711 64 56 18–79
Email: art@arnoldsche.com
www.arnoldsche.com